The New Tattoo

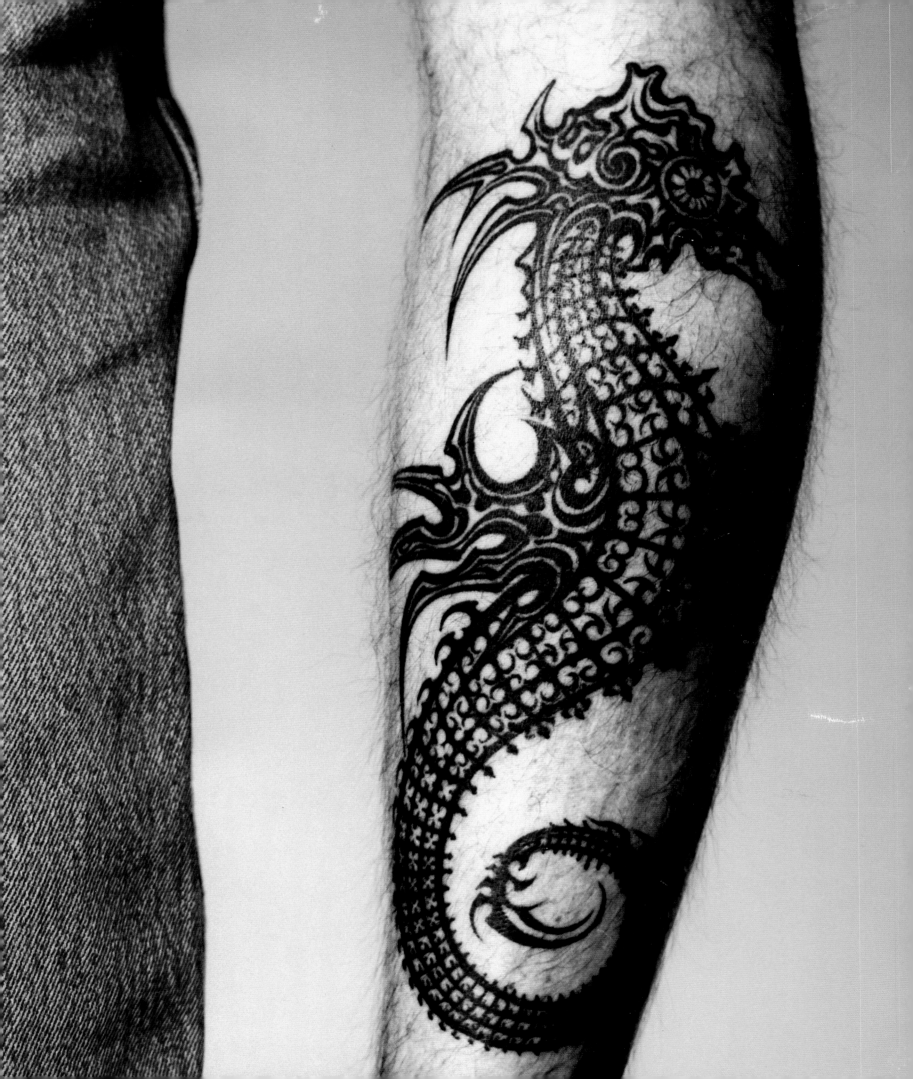

VICTORIA
LAUTMAN

The New Tattoo

PHOTOGRAPHS BY

VICKI BERNDT

ABBEVILLE PRESS
PUBLISHERS
NEW YORK
LONDON
PARIS

To John MacManus, my husband, whose name is tattooed on my heart.
And to my family, with love.

Acknowledgments

Many people helped me with this book, and I'm indebted to all of them. Vicki Berndt was crucial to the project's success—her ability and expertise proved as valuable as her unfailing sense of humor. I probably wouldn't have gotten very far without the early encouragement and continued support of Ed Hardy, to whom I am deeply grateful. And a number of other tattoo artists gave freely of their time and advice; I want to thank in particular Scott Harrison, Jill Jordan, Guy Aitchison, Vyvyn Lazonga, and David Kotker for their help, in addition to Chuck Eldridge of the Tattoo Archive in San Francisco—an invaluable resource. Nancy Grubb of Abbeville Press has long been a great friend and proved far less frightening as an editor than I anticipated; I can't think of anyone I'd rather work with. Molly Shields's elegant design presents the tattoos as the works of art they are. My gratitude to James H. Lorie and Bruce Guenther for their insightful comments on early drafts of this manuscript. And finally, to all my family, friends, and colleagues who were subjected to so many tattoo diatribes yet patiently supported me as I muddled through this book: you have my love and thanks.

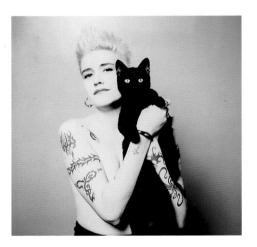

CRYSTAL AND CAT

FRONT COVER: Tattoos by Suzanne Fauser
BACK COVER: Tattoo by Don Ed Hardy
ABOVE: Tattoos by Jill Jordan (arms) and Bill Salmon (heart)
FRONTISPIECE: Tattoo by Robert Vessels
PAGE 6: Tattoo by Alex Binnie
PAGE 20: Tattoo by Alex Binnie
PAGE 42: Tattoo by Jill Jordan
PAGE 62: Tattoo by Guy Aitchison
PAGE 78: Tattoo by Kevin Quinn
PAGE 94: Tattoo by Don Ed Hardy

EDITOR: Nancy Grubb
DESIGNER: Molly Shields
PRODUCTION EDITOR: Owen Dugan
PICTURE EDITOR: Laura Straus
PRODUCTION MANAGER: Simone René

First edition
Library of Congress Cataloging-in-Publication Data
Lautman, Victoria.
The new tattoo / Victoria Lautman ; photographs by Vicki Berndt.
p. cm.
Includes bibliographical references and index.
ISBN 1-55859-785-9
1. Tattooing. I. Berndt, Vicki. II. Title.
GT2345.L38 1994
391'.65—dc20 94-5033

Contents

INTRODUCTION
7

TRIBAL
21

PAINTINGS, PRINTS, AND PORTRAITS
43

IMAGINATION AND FANTASY
63

NEOTRADITIONAL
79

ALL THE REST
95

THE TATTOO PROCESS:
QUESTIONS AND ANSWERS
116

NOTES
119

SELECTED BIBLIOGRAPHY
119

INDEX
120

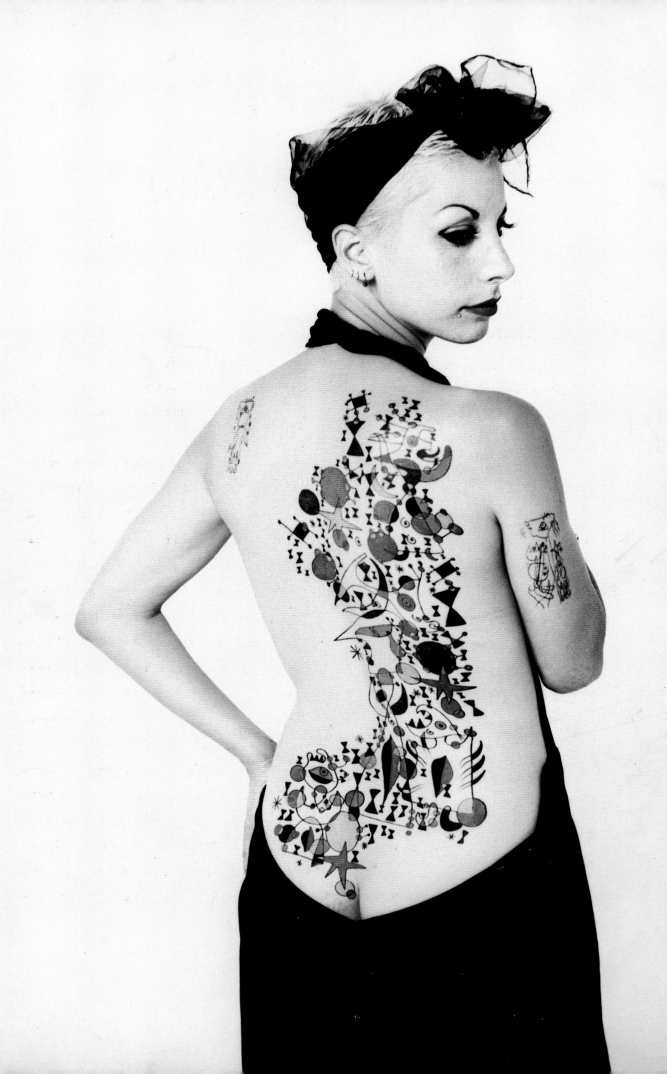

Introduction

Tattoo. What a loaded word, ripe with associations of carnival sideshows, Maori warriors, drunken sailors, rock stars, and the Holocaust. Ask any average middle-class group around a dinner table to express their opinions on the topic of tattooing, and the responses will vary widely. Curiosity, revulsion, titillation, apprehension—everyone will have a bias; everyone will have a reference from personal experience. Few people are ambivalent where tattoos are concerned.

Surely the most common preconception of the tattooee is some sleazy degenerate sporting a torso covered with blurry homages to his girlfriends—a stereotype that links the act of inking skin to society's netherworld. But there is an ever-increasing force of tattoo *artists* at work in the world, and they are supported by a burgeoning audience of tattoo cognoscenti. On campuses and high-fashion runways, in magazines and movies, on television and in bus ads—everywhere that skin is bared there are glimpses of an alternative tattoo domain, one far less ominous than the stereotype. The streets have become a mobile gallery offering glimpses of elaborate monochrome patterns, intricate faux jewelry, fantasy creatures, and images appropriated from van Gogh, Botticelli, and Picasso. These new tattoos are wonderfully inventive and highly skilled artistic expressions. The new tattoo advocates are informed, articulate, and no stranger than anyone else you're likely to meet—indeed, you've already met them, since they represent every aspect of society, from mechanics and waitresses to doctors and lawyers.

Nonetheless, most people will start to squirm just imagining the tattoo process. The suggestion of needles, blood, and pain can cause profound discomfort among the untattooed and, in particular, the needle-phobic. Such squeamishness often disguises an even more primal fear—namely, altering the body forever. There are plenty of precedents in Western and non-Western culture for permanent customizing of the body, and what is desired by one generation is often anathema to another. Having your ears pierced was once considered rebellious; these days pierced earlobes are positively

old-fashioned, given the increasingly popular piercing of noses, tongues, cheeks, lips, nipples, navels, and genitalia.

In 1992 the *Los Angeles Times* called tattooing "the nose job for the 90s," but plastic surgery is still a lot less controversial than tattooing. Let someone etch a permanent bracelet onto her arm or reproduce a favorite artwork on his back and the interrogation begins. (Of course most tattoo aficionados can choose whether to reveal or conceal: your best friend could have a sinuous dragon winding up his leg and you might never know.) "Why did you do it?" That has to be the question most frequently asked of a tattooed person, followed immediately by "Did it hurt?" This book cannot delve into the labyrinth of tattoo psychology, but there are some recurring motivations in Western culture, ranging from the profound (acknowledging a rite of passage, whether an important event or a life transition) to the trivial (getting a tattoo because it's trendy).

One force that compels many devotees of tattooing is the desire to possess something both unique and enduring, sort of a security blanket for the millennium. Many talk about the urge to enhance their bodies in ways they feel are decorative and beautiful, a need that is surely as old as humankind. And the undeniable shock value of tattoos is undoubtedly still luring some people to the buzzing needles, although most wouldn't admit it.

Perhaps the explanation that best illuminates why tattooing has recently grown so popular is that it empowers the wearer, and I don't mean mystically. Tattooing is a basic affirmation of control. In times like these, when so much seems beyond our command, the right and the ability to alter our bodies is, finally, a fiercely affirmative action. This helps explain why tattooing has proliferated in impersonal, rigidly structured environments like prisons and the military: it is one of the few defiant, personal, and expressive gestures available. (Conversely, tattoos have been appropriated as badges of conformity for a number of groups, such as surfers, bikers, groupies, and gangs.)

Most people think of tattooing as a twentieth-century technology. In fact, its practice is both ancient and widespread, a well-documented form of body adornment popular for many thousands of years. Indeed, the Western aversion to tattooing—or at least, mainstream society's condemnation of it—is a relatively recent development compared to the millennia during which pricking skin and inserting ink was an integral part of many civilizations.

Exactly how and when the tattoo process was discovered remains a mystery. Like so many other innovations, it may well have been the result of an accident: some Stone Age klutz fell down near a hearth, found charcoal embedded in his flesh, liked the way it looked, and decided to try to re-create the effect. Preindustrial tattooing required only a simple sharp implement that pierced the skin and fed pigment into the wound. Since the electric tattoo machine wasn't invented until 1891, hand pricking was the only choice for most of tattoo history and is still favored by certain tattooists today.

Finding examples of early tattoos is problematic. Any physical evidence—namely, the skin itself—is preserved only through embalming, intentional or otherwise. There may well have been tattoo devotees ten thousand or more years ago, but the oldest tangible proof of tattooing is more recent. In 1991 a Neolithic hunter was discovered trapped in the Similaun Glacier, high in the Italian Alps, which had preserved his body for fifty-three hundred years. This so-called Iceman startled the world not only with the sophistication of his clothes and tools but also with the clearly visible linear tattoos on his back and behind his knee. Thus, in an odd quirk of fate, the oldest intact specimen of mankind is also the earliest-known tattooed individual.

Before the Iceman's discovery, the first known tattoo was on an Eleventh Dynasty (Middle Kingdom) mummy whose name was Amunet. This former Egyptian priestess of the goddess Hathor had lived in Thebes around 2000 B.C. and, like the Iceman, she had

tattoos that were simple and graphic—far from the more elaborate pictorial tattoos found later in history. Amunet's abstract patterns of dots and lines included a delicate elliptical design on her lower abdomen that could have been fertility related.[1] Two other female mummies from the same period—one of whom had been a dancer—sport similar markings, so until a tattooed male mummy surfaces it seems that in Egypt tattooing was for women only.

One can only speculate about the meaning of these prehistoric tattoos as talismans, magical medicine, tribal markers, or pure decoration. But judging from the historical record, having one's epidermis engraved and colored was not something that occurred on the spur of the moment. The process was far more laborious and painful than it is today, employing instruments and techniques that would make a contemporary needle-phobe quiver with anxiety: the Burmese fashioned needles from two-foot-long pieces of bamboo, the Maori actually chiseled designs into the skin, and the Eskimo drew threads darkened with soot through and under the skin.

Wherever tattooing appears on the cultural-historical timeline, it has inevitably set apart its recipients as "special" in some not always positive way. Whether denoting members of the ruling class, the priestly class, or even just to identify slaves and criminals, each culture's use of tattoos signified something different, something other than the standard. One of the most eloquent early examples of the tattoo as a mark of special status was discovered during a 1948 excavation in Pazyryk, Siberia. There, a frozen burial mound yielded the preserved body of a twenty-five-hundred-year-old Scythian chieftain, a nomadic warrior with elaborately tattooed skin. Spilling down both arms, one leg, and all across his chest and back were designs that had been pricked or sewn into his skin with soot to form fish, sheep, rams, and a host of mythical creatures worthy of Hieronymous Bosch. The designs, apparently created many years before the chief's death, are thought to have been badges of his noble birth.[2]

By 1000 B.C. tattooing had made its way virtually around the world, probably diffused from the Middle East along trade routes by land and sea to India, China, Japan, and the Pacific Islands.[3] Archaeological and literary references thereafter occur more and more frequently, with some noteworthy highpoints. Many classical writers, including Xenophon, Pomponius Mela, and Hippocrates, refer to the custom, which was a badge of wealth, status, or high birth among their neighbors. Even Herodotus remarked around the year 450 B.C. that "tattooing among [the Thracians] marks noble birth, and the want of it low birth." Herodotus also tells the story of a trusted slave whose scalp was tattooed with a secret message visible only when his head was shaved.[4]

But as to the existence of tattooing in other cultures from this time, the record can be maddeningly mute. There are artifacts that, by extension, hint at a tattooed population, but more tangible proof may never materialize. For instance, do the incised facial markings on figurative pottery from prehistoric Japan (Jōmon Period) indicate tattoos, as is sometimes argued,[5] or some other form of body decoration, or just a nice design? Similar conjectures are possible for dozens of other cultures, including those in North America, where prehistoric Alaskan objects are carved with tattoo-like lines that conform to actual tattoos observed by explorers, centuries later, on Native Americans.[6]

Elsewhere in the world, tattooing had a more measurable impact on the local populations. Two early indigenous tribes of the British Isles—the Picts and the Britons—actually derived their names from a fierce devotion to tattooing. They covered their faces and bodies with colorful figurative images that terrified invaders. Depending on which explanation you accept, the Picts got their name either from a Celtic root word meaning "etched," from the fact that they used a picklike instrument to create the tattoos, or from a Latin word meaning "to paint." The Britons' name stems from a Breton word meaning "painted in various colors."[7]

Nomenclature notwithstanding, invading Roman soldiers in the third century A.D. were so impressed by the Pictish tattoos that they returned to Rome with souvenir body etchings of their own, allegedly causing the newly converted Christian Emperor Constantine to issue a decree against the process, because it damaged what God had fashioned. This fundamentalist response was adopted by several religions over the centuries and is responsible for both promotion of and resistance to the process. The Old Testament book of Leviticus (19:28) bluntly states "You shall not make any cuttings in your flesh on account of the dead or tattoo any marks upon you." On the other hand, several New Testament passages imply that Jesus' followers identified themselves by tattoos on their foreheads (Galatians 6:17; Revelations 7:3 and 22:4).[8] Even though the Koran forbids tattooing, it became popular in Moslem lands, encouraged by the belief that any marks on the body will be removed in the fiery purification process prior to the soul's entering Paradise.[9]

Tattooing seems to have declined in Europe after the third century A.D., but there was still enough enthusiasm for the process to alarm Pope Adrian I nearly five hundred years later. He, too, allegedly issued a ban against tattooing in A.D. 787, but still the tenacious practice continued. According to a gruesome story passed down from the Battle of Hastings, in 1066, the identification of King Harold's mutilated body depended entirely on "marks" (presumed to be tattoos) known only to his lover Eadgyth, who was brought onto the battlefield to locate the king.[10] Tattooing even played a part during the Crusades to the Holy Land over the next two centuries, when religious warriors had themselves inscribed with a crucifix or other symbols of their faith to make certain they would get a Christian burial if they died abroad.[11] In later centuries, pilgrims who wanted some souvenir of their journey to Jerusalem collected similar tattoos as a permanent spiritual memento, and there are a number of sixteenth- and seventeenth-century texts that report on the process explicitly.[12] Even the Prince of Wales and several members of the Russian imperial family collected tattoos during visits to Jerusalem in the late nineteenth century.

Wherever explorers wandered, there they found tattooing. Marco Polo made several references to "etched" populations in his *Travels,* compiled during his thirteenth-century Asian sojourn. He noted that in Yunnan (in southern China) there were "bands or fillets pricked in black on men's arms and legs. . . . It is considered a piece of elegance and the sign of gentility to have this black band."[13] In the area of today's Laos and Burma, too, "The whole of the people, or nearly so, have their skin marked with the needle in patterns representing lions, dragons, birds, and what not . . . and they look on it as a token of elegance, so that those who have the largest amount of this embroidery are regarded with greatest admiration."[14]

The New World offered its share of tattooed denizens as well. From North to Central to South America, tattooing was nearly universal among the Indians, although neither the Hopi nor the Aztecs appear to have adopted the custom. Early explorers viewed the natives' "permanent stains" and "thorn-pricks in flesh" with such awe that they captured some of the tattooed inhabitants and exported them to Europe. Indeed, one broadside from 1566 in the German city of Augsburg advertised an Eskimo woman and child from Newfoundland, whose "marks cannot be taken off again with any substance."[15] In exhibition halls and stylish European drawing rooms the captives (soon augmented by South Sea Islanders) were ogled and prodded. Prince Jeoly of Meangis Island, probably the first tattooed Polynesian to be seen in Europe, was brought to England in 1691, where he soon died of smallpox. A parade of others followed, including Omai of Tahiti in the 1770s, transported by explorer Captain James Cook himself. The era of the "tattooed human spectacle" had begun, a phenomenon that would eventually lead to the deliberate tattooing-for-show—the inking of skin to earn a living—and the association of an ancient practice with carnival sideshows.

Captain Cook is credited with awakening and popularizing Western interest in tattoos, not only by bringing living examples of the art back from distant regions but also by writing at length about the process and its various manifestations (as did other members of his entourage). Sailors from Cook's voyages initiated the tradition of the tattooed seaman, and the word *tattoo* itself, which derives from the Polynesian *ta,* meaning "to knock or strike," can be traced to his journeys. (Adopted into many languages, *tattoo* translates into *tatowirung* in German, *tatouage* in French, and *tatuaggio* in Italian.)

It was Cook's trip to New Zealand that led to the discovery of the incomparable Maori art of moko, a discovery that ultimately had grisly consequences for the Maori people. Mokos are the elaborate black spirals, stripes, and patterns chiseled into the faces of Maori men and women, a process that required great skill, took many months, and caused much pain. As badges of status and identity, moko-adorned heads were so prized among the combative Maoris that they carefully preserved the decorated heads of their murdered enemies. This in turn spawned a ghastly European craze for collecting mokoed heads, beginning in the late eighteenth century. It seems that, after initial reluctance to part with their trophies, the Maoris began to exchange them for guns. The killings proliferated to satisfy the new demand, and if no heads became available through combat, prisoners were forcibly tattooed and hastily executed.[16] Finally, in 1831, the colonial governor passed an act making the possession of the heads a crime, and afterwards, with no commercial impetus and the per-

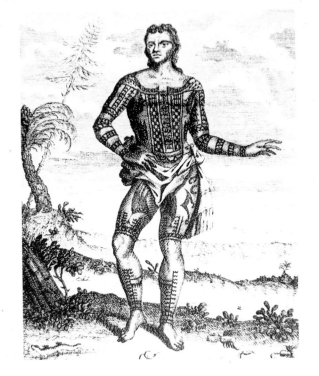

PRINCE JEOLY (DRAWN BY F. SAVAGE)

sistent disapproval of missionaries, moko tattooing tapered off, essentially dying out among the Maoris by the turn of the twentieth century. In the last twenty years, however, through the interest and research of contemporary tattoo artists, moko designs and tribal motifs from all sorts of native populations have begun to proliferate among tattoo aficionados in America and Europe.

At the same time that Europeans were being titillated by the marvel of tattooing, the Japanese were undergoing a reevaluation of the process within their own culture. The indigenous Ainu of Hokkaido had made use of tattoos for centuries (an exclusively female ritual, in which the women marked the backs of their hands and around their mouths), and the legend of Japan's first emperor, Jimmu Tenno, is embroidered with references to his opulent tattoos.[17] Jimmu's fabled etchings did not encourage subsequent emperors to condone the practice as a physical enhancement; instead, tattooing was used to punish criminals as early as the fifth century A.D., after which it continued as a sentence, off and on, for the next twelve hundred years.[18] Like other corporal punishments, such as the lopping off of an ear or hand, inflicting a tattoo immediately identified the bearer's misbehavior. Perhaps that is what inspired Japanese prostitutes of the seventeenth century to acquire small tattoos themselves, and this double association with criminality and prostitution relegated tattoos to the Japanese underworld.

It was a fourteenth-century Chinese novel celebrating a group of 108 heroic rebels, many of whom sported full-body tattoos,

that was the catalyst for what was to become modern tattooing in Japan. Translations of *Suikoden* (called *The Water Margin* in English and *All Men Are Brothers* in Pearl S. Buck's 1933 version) became widely available in Japan's mid-eighteenth-century Edo period, and by the start of the next century editions of the book illustrated by the prominent wood-block artists Hokusai, Kuniyoshi, and others were in huge demand. A tattoo craze based on these illustrations and the heroic characters ensued, particularly among members of Japan's more raucous and often bareskinned trades, such as the fire brigades, carpenters, and palanquin bearers.[19] Thus, the complex forms of Japan's formalized figurative art with its rich use of myth and metaphor began to be applied to an entirely new medium—the body. Emulating the literary heroes that inspired them, these designs weren't puny images adorning a bicep or a pectoral muscle, but full-scale artworks that flowed over the entire chest, back, sides, and limbs.

This extravagance lasted until 1872, when Emperor Matsuhito decided to open Japan to the outside world and became concerned about the impression that tattoos might make on foreign visitors. He officially prohibited the process as an embarrassing sign of barbarism, even though, ironically, it was the foreigners who were often most appreciative of the tattooists' work. Queen Victoria's grandsons Prince George and Prince Albert were both tattooed in Japan, along with the Russian heir Nicholas II. Nevertheless, the Japanese art of tattooing was forced underground until after World War II. Though no longer illegal, it became associated exclusively with gangsters, or *yakuza*—the only segment of

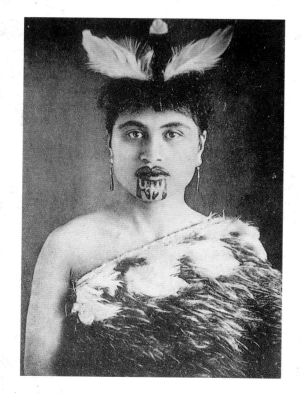

A Maori woman with tattooed lips and chin

society willing to risk what could only result in social ostracism. Today, although tattooing is still considered a deviant practice by most Japanese, a younger group of tattoo fanciers has come under Western influence. A macabre point of interest is that Japan possesses the only known collection of modern tattooed human hides, preserved at the Medical Pathology Museum of Tokyo University. The hundred-plus skins were all collected as masterpieces of the art form with the complete cooperation of the tattooees and their families.

Emperor Matsuhito had banned tattooing just when it was gaining momentum in the West. Indeed, it was a fad that consumed Europe's upper classes, with detailed newspaper accounts of the royal tattoos adorning Kaiser Wilhelm of Germany, Princess Waldemar of Denmark, King George of Greece, and most male members of the English royal family. Even Winston Churchill's mother had a tattooed snake entwined around her wrist like a reptilian bracelet. In America, where the process had long existed among the native population, inking skin achieved mass popularity only during the Civil War period. As early as the 1830s circuses had flaunted their share of tattooed natives and "freaks," with P. T. Barnum's Prince Constantin (he of the 388 tattoos on every inch of his body, including eyelids and penis) attracting international attention in the 1870s and 1880s.[20] Tattooing became most popular with soldiers and sailors as a bonding ritual, although a few members of high society surrendered to its allure as well, including the prominent San Franciscan Amy Crocker, who took great pride in displaying her elaborately tattooed arms at parties all over the world.[21]

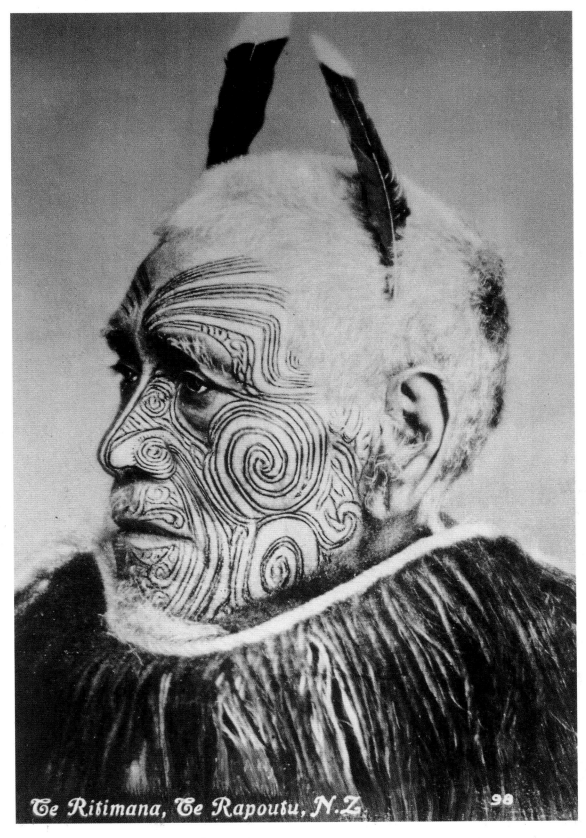

Te Ritimana, Te Rapoutu, N.Z. 98

A Maori warrior with moko tattoos

Until the cusp of the twentieth century, the laborious process of tattooing was entirely handwrought, from preliminary drawing to transfer of design to execution. But the technological gains of the industrial age filtered into tattoodom and instigated a commercial revolution of sorts. It began in New York with the tattooist "Professor" Samuel O'Reilly's patent for the electric needle —or "tattaugraph"—in 1891. This newfangled cross between a dentist's drill and ballpoint pen ultimately led to the modern, high-speed machines used today, which are capable of between 2,000 and 3,000 pricks per minute, as compared to the 90 to 120 hand-tapped prickings of a Japanese master.

At the same moment, O'Reilly's Bowery colleague Lew Albertis (better known as Lew the Jew), a former wallpaper designer turned tattooist, became the first to create sheets of standard tattoo patterns that could be sold over and over again to other shops. As another time- and labor-saving innovation, these progenitors of what in professional parlance is now called "flash" allowed every tattooist to speed up output by simply tracing someone else's designs. And thanks to O'Reilly's new electric needle, the entire process was now also far less painful.[22] The era of modern tattooing was at hand.

Since O'Reilly's and Albertis's inventions at the turn of the century, tattooing has undergone a roller-coaster ride in terms of its popular appeal. The initial whirl of activity among the social elite soon gave way to aversion as the excitement spawned by the new electric needle died down and stories began to appear in the media linking tattooing to criminal behavior, venereal disease, loose morals—in short, everything from which the emerging middle class was striving to distance itself. There was a flutter of renewed general interest in the teens and twenties when cosmetic tattooing became a brief fad. England's famed tattooist George Burchett estimated that at least half of his business around 1913 was devoted to fashionable women demanding to have their eyebrows permanently arched and dyed, their lips and cheeks reddened.[23]

But it was also during the 1920s and 1930s that the cliché of the tattooed "freak" solidified into the present-day prejudice. During the Depression more men and women than ever became tattooed in order to earn a living by exhibiting themselves in carnivals and circuses, often weaving into their performance lurid stories that involved abduction and tattooing by force. These successors of the Native Americans, Maoris, and Marquesans who had made the rounds of European parlors a century earlier were usually the only examples of tattooed individuals encountered by the middle-class mainstream, so the association of tattoos with "outsiders" developed quite naturally. It is not surprising that tattoos were subsequently adopted as the insignia of self-styled outcasts and outlaws. The seemingly mandatory tattoos gathered by soldiers and sailors wherever they were stationed could be (and often still are) chalked up to youthful folly—forgiven as long as they were kept hidden or, better yet, removed after one's tour of duty was completed.

And that was the extent of the tattooing phenomenon until the 1960s. Almost exclusively the province of servicemen and assorted "deviants," it was a process carried out in seedy neighborhoods by characters as colorful as their clients, using a system based on jealously guarded secrets. In general, tattooists rarely communicated with each other, nor did they seek to establish the art of tattooing as something distinguishable from the procedure of tattooing. To most, it was simply a decent-paying job with a certain decadent cachet. The flash displayed in shops went relatively unchanged for decades, with little innovation or evolution. Sailing ships, American flags and eagles, and religious iconography were ubiquitous, along with one of the most widely tattooed designs of all—the snarling and clawing panther. Busty "girlies" in every state of undress were another flash staple, sharing wall space with a wide array of daggers, hearts, roses, and name-emblazoned banners. Color choices were narrow, with red, green, yellow, and black predominating. The point was to be quick and legible, and despite the

occasional tattooer who tried to encourage clients to get quality custom work, a broad market for unique, artistic tattoos simply did not exist outside of Japan.

One tattoo visionary of the mid-twentieth century was Norman Keith "Sailor Jerry" Collins, who is repeatedly credited with having expanded the boundaries of tattooing and hastening the new creative era. Sailor Jerry spent most of his sixty-plus years alternately sailing the world and operating a succession of tattoo shops in Honolulu, all the while nurturing a dream of elevating both the quality and the status of tattooing. His particular gift was an ability to absorb and meld two disparate tattoo traditions. In America the common approach was to accumulate one or more separate images, frequently by different tattooists, into a pastiche that used the body as a sort of graphic bulletin board, with little thought to placement or the relationship of one image to another. Characterized by heavy black outlines, solid blocks of unmodulated color, and the archetypal themes of love, death, war, and family, the

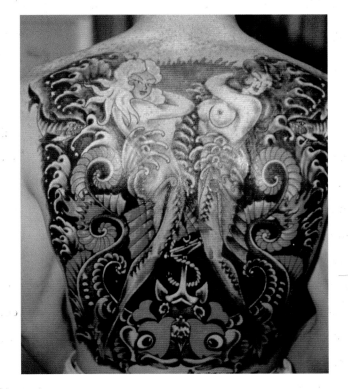

A RARE "SAILOR JERRY" COLLINS BACK PIECE FROM 1967

classic American-style tattoos contrasted utterly with Japan's tradition. There, large-scale, fully integrated designs created by a single skilled artist covered huge areas of the body and resembled decorative suits, all based on traditional, centuries-old Asian designs. Wild-eyed dragons were among the most popular motifs, their undulating scales individually delineated and shaded. Another mythological favorite was Kintaro, a mighty superboy of sorts, typically shown with rosy complexion and wrestling a giant koi. Gods, goddesses, and heroes from *Suikoden* mingled with peonies, goldfish, and elegant cranes, the designs visually unified by stylized bands of clouds.

Sailor Jerry helped foster the emergence of a new sensibility by encouraging big, unified, custom-created designs with subtle blends of color, sophisticated shading, refined outlines, and an insistence on high quality of execution. He also carried on correspondence with other tattooers throughout the world, developing a network of communication that simply had not existed earlier, so that members of the profession began to compare ideas and techniques, trade sheets of flash, and generally see themselves as a united international group rather than isolated renegades working in a vacuum. By the time Sailor Jerry died, in 1973, the tattoo revolution was gaining momentum.

The countercultural paroxysms of the late 1960s and early 1970s opened so many innovative paths of personal expression that it was almost inevitable that tattooing would undergo a reexamination. Here was a powerful and startling alternative to mainstream body decoration that would immediately establish the bearer's nonconformist status and could be tailored to illustrate themes related to rock 'n' roll, drugs, or the peace movement. Not only that, but tattoos were guaranteed to drive most parents crazy. Naked skin was more conspicuous than ever: barefoot, bare-chested, braless, and miniskirted citizens abounded, and the epidermis became a fashion statement in its own right. Is it any wonder that bodies suddenly offered new potential as surfaces to be painted, stenciled, pierced, and tattooed?

15

Thus, public consciousness about this wayward art form began to change. Glancing through newspaper and periodical indexes for tattoo stories between the 1940s and 1970s is like watching a tiny, wrinkled raisin expand into a big, juicy grape. Until about 1960 articles on tattooing were rare at best. When they did appear, the focus was generally on tattoos' predominance in (1) the underworld—"Japanese Gamblers Decorate Themselves" (1946) and "How Tattoos Help Cops Catch Crooks" (1959); (2) the armed services—"Tattoos Cover Acres of U.S. Sailors' Skin" (1940) and "War Booms the Tattooing Art" (1943); or (3) primitive societies—"Personal Ornamentation among Natives on Malaita Island" (1946)—not to mention persistent reports on using tattoos to identify animals. The horrific Nazi practice of tattooing identification numbers on concentration-camp prisoners during World War II was addressed tangentially in pieces about the war.

Then, about 1968, articles like *Redbook*'s dainty "How to Tattoo Like a Lady" began cropping up, along with details about the much-ballyhooed tattoo renaissance in periodicals like *Time* and *Rolling Stone*. All of this publicity expanded the flourishing tattoo clientele, which by this time included rock 'n' rollers, hippies, celebrities, and more women than ever. Even the mainstream art world got in on the excitement when in 1971 the Museum of American Folk Art in New York organized a small but popular exhibition—possibly the first museum show in tattoo history—that re-created a real tattoo parlor with all its exotic flash and accoutrements as well as showcasing designs by Sailor Jerry and emerging artists like Don Ed Hardy. The exhibition was roundly criticized in *Newsweek* for celebrating something that was strictly kitsch and best kept out of museums.

Tattooing was not just tentatively emerging from the shadows, it was jumping out and stamping its foot. Some sort of vortex had been created by the freewheeling times, the self-expressive clientele, and the steady media commentary. A new breed of tat-too artist came forward in the 1960s and 1970s—a wave of ink-and-needle-wielding men and women no longer content with the traditional limits of their profession. Unlike the generations of tattooists before them, many of these folks were art-school trained, and they saw tattooing as a perfectly valid art form, with its own history and aesthetics, that had never gotten its due (not unlike the critical neglect faced by photography decades before). They saw the human body not merely as a bulletin board for tattoos but as a fully three-dimensional object whose movements and contours had to be considered before a tattoo could be placed on it. And, although pursuing a career in tattooing may have been unorthodox, it offered a deeply compelling, psychologically rich alternative to the conventional artist's milieu of galleries, dealers, exhibitions, reviews, and sales.

Many gifted artists were doing innovative and influential work at this moment in tattoo history, but a few have achieved apotheosis into the tattoo pantheon and are regularly cited as crucial influences. In fact, an informal dynasty has become evident in the tattoo world. After Sailor Jerry, there was Phil (Sam Steward) Sparrow, a former Loyola University English professor who opened shops in Chicago, Milwaukee, and Oakland. Interested in all styles, he developed a thoughtful, intellectual approach to tattooing. Like Sailor Jerry, Sparrow championed Japanese tattooing in the 1950s and 1960s when it was still exotic and little known, and it was his unique vision that captivated another seminal tattoo artist, Cliff Raven. Raven had earned a degree in fine arts and established a commercial art career before encountering Sparrow in Chicago in 1958; eventually he devoted himself full time to tattooing in shops around that city and later Los Angeles.[24] It is Raven who is credited both with resurrecting the now-popular motifs of tribal cultures back in the early 1960s, when those traditions were not yet widely known in the West, and with imbuing his work with an artist's sensibility by melding several styles at once. Raven, in fact, was

named Tattoo Artist of the Year in 1976 at the first international tattoo convention, in Houston.

One of the most influential tattoo artists, past and present, is Don Ed Hardy, a product of the California hot-rod culture and the San Francisco Art Institute, from which he graduated with a B.F.A. in 1967. He got his first tattoos in 1966 from Phil Sparrow (in Oakland), and like Cliff Raven was deeply impressed with the sophistication of Sparrow's vision and work environment. Hardy underwent what he describes as a "lightweight apprenticeship" before devoting himself to elevating the idea of what tattoos could be. He corresponded with Sailor Jerry; traveled to Japan to study traditional techniques; opened a succession of shops in Vancouver, San Diego, Los Angeles, and San Francisco; and became a visiting artist at colleagues' shops all over the world.

Over the past twenty years Hardy has become a self-styled tattoo ambassador-at-large, even publishing a glossy periodical called *Tattootime,* beginning in 1982. He has organized exhibitions and lectures, advised dozens of would-be tattooists, and provided work in his shops for some of the most talented, such as Greg Irons, Bob Roberts, Bill Salmon, and Jamie Summers in the early days, and more recently Fred Corbin, Eddy Deutsche, and Daniel Higgs.

Sparrow, Raven, and Hardy were not the only contributors to the tattoo revolution, just some of the most influential. Women also played a pivotal role, shouldering their way into the traditionally macho domain. In the 1970s Vyvyn Lazonga, now in Seattle; Suzanne Fauser of Ann Arbor, Michigan; Jamie Summers, who died in 1983; and Kandi Everett of Honolulu were all helping to shift tattoos away from fashionable little rainbows, flowers, and unicorns to the larger, fine-arts-related custom designs. Today some of the most respected artists in the business are women, including Los Angeles–based Jill Jordan and Laura Vida of San Francisco.

The tattoos available in previous decades had been fairly homogeneous, varying only somewhat depending on the tattooist.

But the growing acceptance of custom designs promoted all kinds of experimentation in the 1960s and 1970s, and individual styles soon emerged, with certain artists becoming known for specific types of work. There were photo-realistic "fineline" tattoos incorporating portraiture and using a single needle instead of the typical cluster of three, five, or more. Inspired by Chicano barrio culture, fineline was popularized thanks to the efforts of artists like Freddy Negrete, Jack Rudy, Charlie Cartwright, and Shotsie Gorman. In Hawaii, Sailor Jerry's shop-heir, Michael Malone, was trying out native motifs and full-body Japanese-style work. Radical psychedelic designs by Bob Roberts were a big hit on the West Coast, while abstract conceptual tattoos—like bar codes, color charts, radar patterns, and dotted lines—were finding their own public too. Once artists realized there was no rein on their imaginations, images from fine art, dreams, literature, and every corner of daily life could be seen on someone's body.

Despite the different styles and locales of these tattoo pioneers, they were all similarly distinguished from their forebears in important ways. Not only did they see the tattoo medium as something that transcended the merely technical, but they were also no longer content to rely solely on flash designs that could appear on thousands of people. These artists drew their own ideas freehand, and the customized results were far removed from typical flash—a good comparison might be an innovative, finely wrought drawing versus a standard, mass-produced greeting card. (Many tattooists, including Raven, Hardy, Irons, and Roberts, went on to publish popular editions of their own flash that are still in wide use, along with that of younger artists.) A new client-artist relationship developed as a result: instead of picking an image from dozens of printed designs and having it copied onto their skin, customers consulted with their artist, discussed the desired tattoo at length, and reviewed preliminary sketches, which could be modified until the final, perfected design materialized.

It was (and continues to be) a relationship that mirrored the commission process between any patron and artist—a creative collaboration that brought the tattoo trade further into the realm of fine-art legitimacy.

Not surprisingly, even the physical trappings of the tattoo business began to change as it attracted a new middle-class clientele, often from walks of life never before associated with tattooing. Prior to the 1960s "street shops" were the standard tattoo venue: storefronts with eye-catching signage, walls laden with flash, and customers waiting their turns on a drop-in, first-come-first-served basis. The shops, though atmospheric, could also be frenetic and not particularly conducive to creative pursuits. Gradually, tattoo parlors or studios became established where walk-in trade was discouraged and reservations often required. (Hardy and other renowned tattoo artists now book appointments many months in advance.) This new setup had obvious advantages for both the client and the artist: the more controlled, private environment was free from the potential dangers (drunks, fights, robberies) that plagued street shops, and it bestowed far more respectability on the tattooist, who could then decide when to work and on whom—a significant departure from earlier tattoo tradition. Thanks to these creative and commercial innovations, today's tattoo artists have more freedom and options than ever before. Some still prefer to work in lively street shops, with the financial benefits of high turnover and the potential for custom clients on the side; others work exclusively from private studios.

From a technical point of view, the tattoo artist has plenty to master. An understanding not only of anatomy, but also of color, line, form, and the quirky constraints of the medium itself are all prerequisites. In a field that offers no classes and demands no licensing or diplomas, a field that is rife with competitive, often suspicious practitioners, gaining access to training is not always easy. The competitiveness is understandable in light of the facts: Hardy estimates that there are about ten thousand American-based tattooers working today, as opposed to about five hundred in the mid-1960s.[25] Sure, anyone can buy the equipment and practice on themselves, their friends, or a thick-skinned grapefruit. But as in a medieval guild system, the most respected route to tattoo success is through a lengthy apprenticeship with an established professional (two to four years is not out of the question), and finding an amenable teacher isn't guaranteed in today's crowded market. Consequently, many working tattooists are self-taught, learning the rudiments and developing their own techniques over time by accumulating tattoos on themselves and spending as much time as possible among experts. With dedication and high-quality work, a self-taught tattooist can build a career and respectability in tattoo circles, here and abroad.

A second wave of tattooing is now being carried along on the crest of a fashion for body modification that encompasses piercing, scarification, and branding. Tattoos by renowned artists, the equivalent of blue-chip modern masters in the contemporary art world, are being collected on people's bodies like paintings on the wall. Up-and-coming young talent is sought out coast to coast, and every month there is at least one tattoo convention somewhere in America, paralleled by similar events in Europe. There are nearly a dozen tattoo-related publications at newsstands, spreading new ideas and information, and tattooists routinely travel to each other's studios for extended visiting-artist exchanges. Even old sheets of flash are being sold in galleries for hundreds of dollars as hot collectibles on the folk-art circuit, and many of the pre-1960s old-schoolers bemoan the trendiness that has overtaken their once renegade world.

Like the art world at large, the tattoo domain has its own customs and creative trends. At the moment, classic Sailor Jerry designs are being revived, and the popularity of any type of tribal tattoo also implies a certain nostalgia for times past. But concur-

rently there is a big demand for futuristic science-fiction creations, ranging from gruesome monsters to gear-packed biomechanical wonders, with artists like H. R. Giger (of *Alien* movie fame) and Robert Williams having their work enthusiastically appropriated by the tattoo world. On the other end of the spectrum, elements of hip-hop and graffiti culture have lately crept in, with blocky, brash lettering and dazzling color combinations that reflect contemporary pop culture. The following pages of tattoos represent only a tiny fraction of the innovative, high-quality work that constitutes this contemporary international pageant, and there are many other artists whose achievements warrant appreciation. This, then, is just another starting point in the millennia-long history of the tattoo as art form.

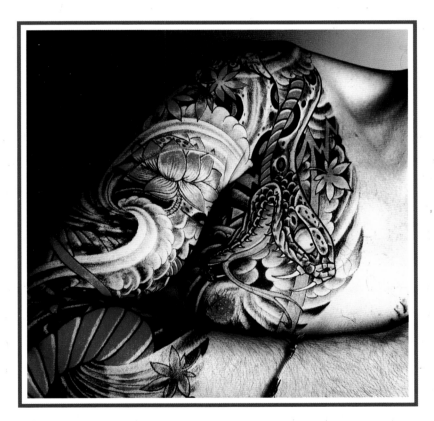

DON ED HARDY

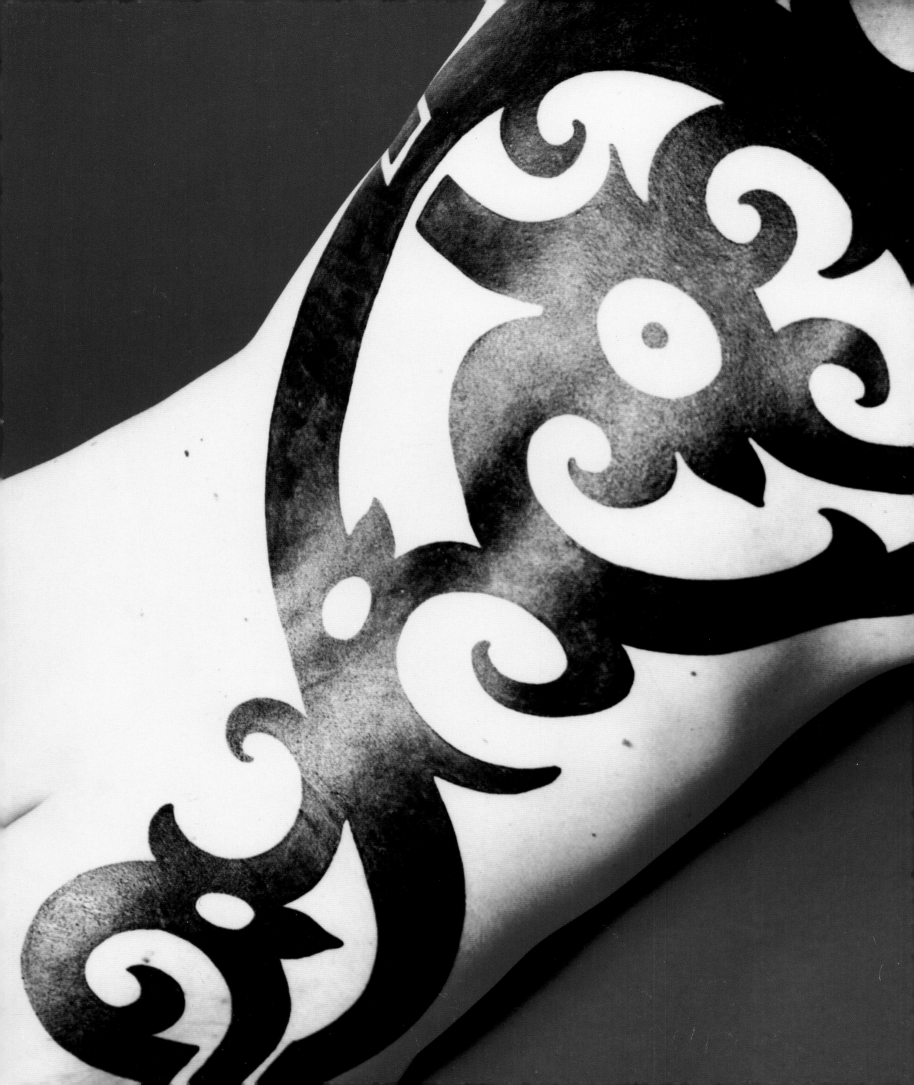

Tribal

One of the most intriguing styles to emerge with the tattoo renaissance is the strikingly graphic tribal work that has thrived since the 1960s. The term *tribal* encompasses native motifs from preindustrial cultures the world over; today's tribal tattoos might derive from the Sea Dayak of Borneo (PAGE 20), New Zealand's Maoris (PAGE 27), America's Haida (PAGE 25) and Hopi (PAGE 30), or the indigenous Hawaiian Islanders (PAGE 29).

The fact that these bold monochromatic designs are among the oldest motifs in tattoo history did not keep them from near extinction. By the mid-twentieth century, decades of cultural assimilation had nearly erased these remarkable decorative traditions. But a few peripatetic tattoo artists familiar with tribal motifs catalyzed a resurgence of interest in them that continues with unabated momentum. Cliff Raven, Dan Thomé, Roger Ingerton, Michael Malone, and Kandi Everett, as well as tattoo historian Leo Brereton, were all champions of tribal styles as early as the 1960s. It wasn't until the early 1980s, though, that an explosion of interest in the tribal style was sparked by an all-tribal issue of *Tattootime* and reinforced by the popularity of these forceful black patterns with punk rockers.

The tattooist perhaps most associated with tribal work in America is Leo Zulueta, whose design vocabulary is based almost exclusively on the traditions of Pacific cultures, including Polynesia, Micronesia, and Borneo. Even before he became a tattooist, in 1981 Zulueta acquired a traditional Micronesian back piece (similar to the one on PAGE 41), which had as strong an impact on the field as that of the Japanese-style tattoos a generation earlier.

Today, tribal motifs take many forms, even making their way into sets of flash and onto the racks of popular temporary tattoos. Why the popularity? For one thing, tribal work looks startlingly different from other tattoo styles, a counterpoint to the wildly colorful images that have been tattooing's mainstay since the 1960s. Also, tribal motifs adapt splendidly to individual anatomy, accentuating each body's own structure and contours (PAGE 26).

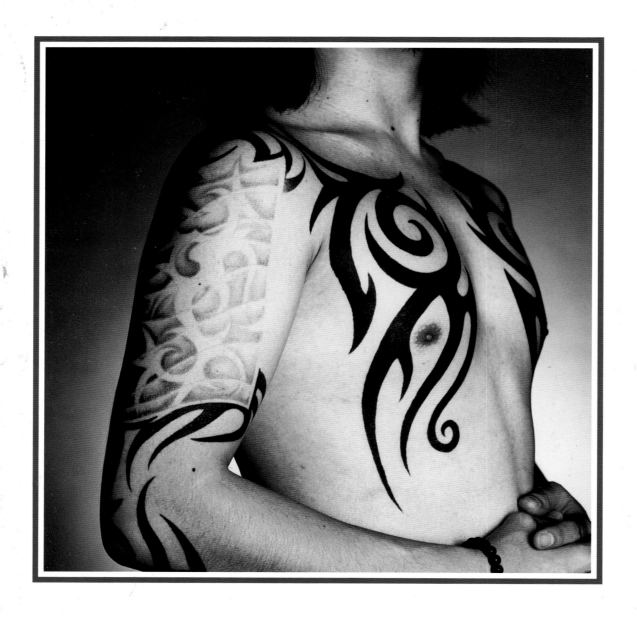

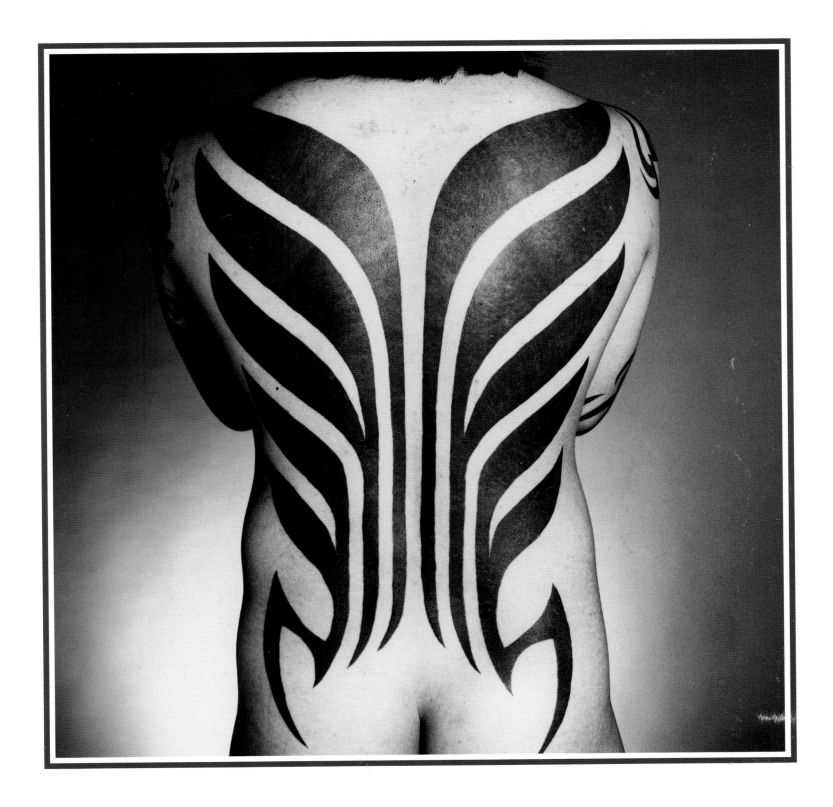

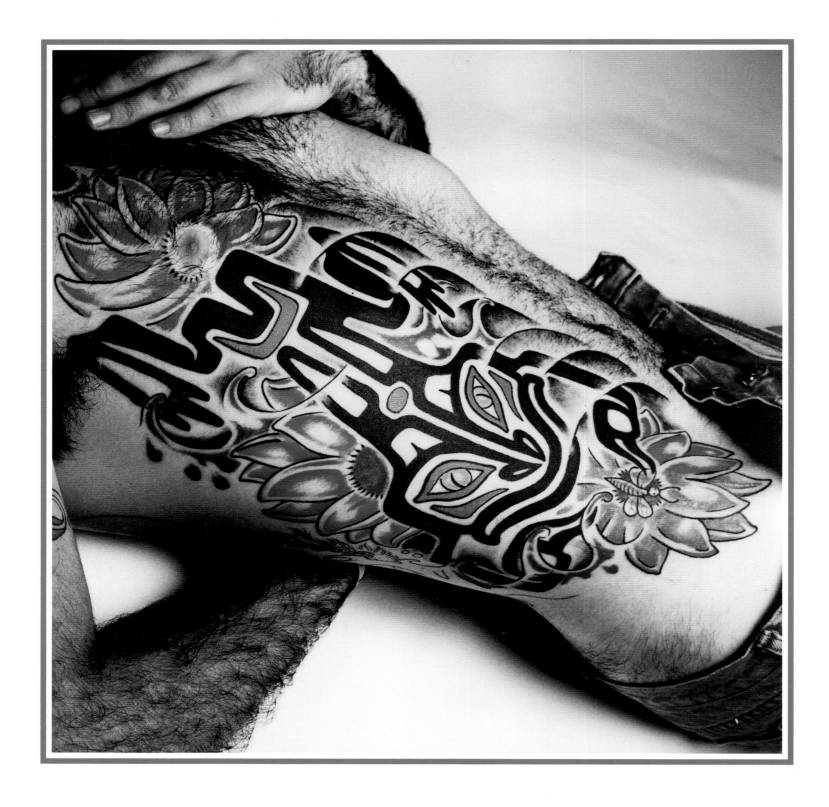

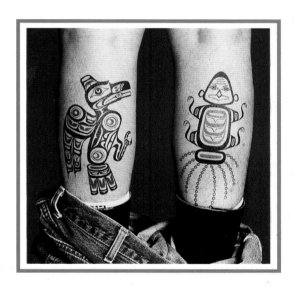

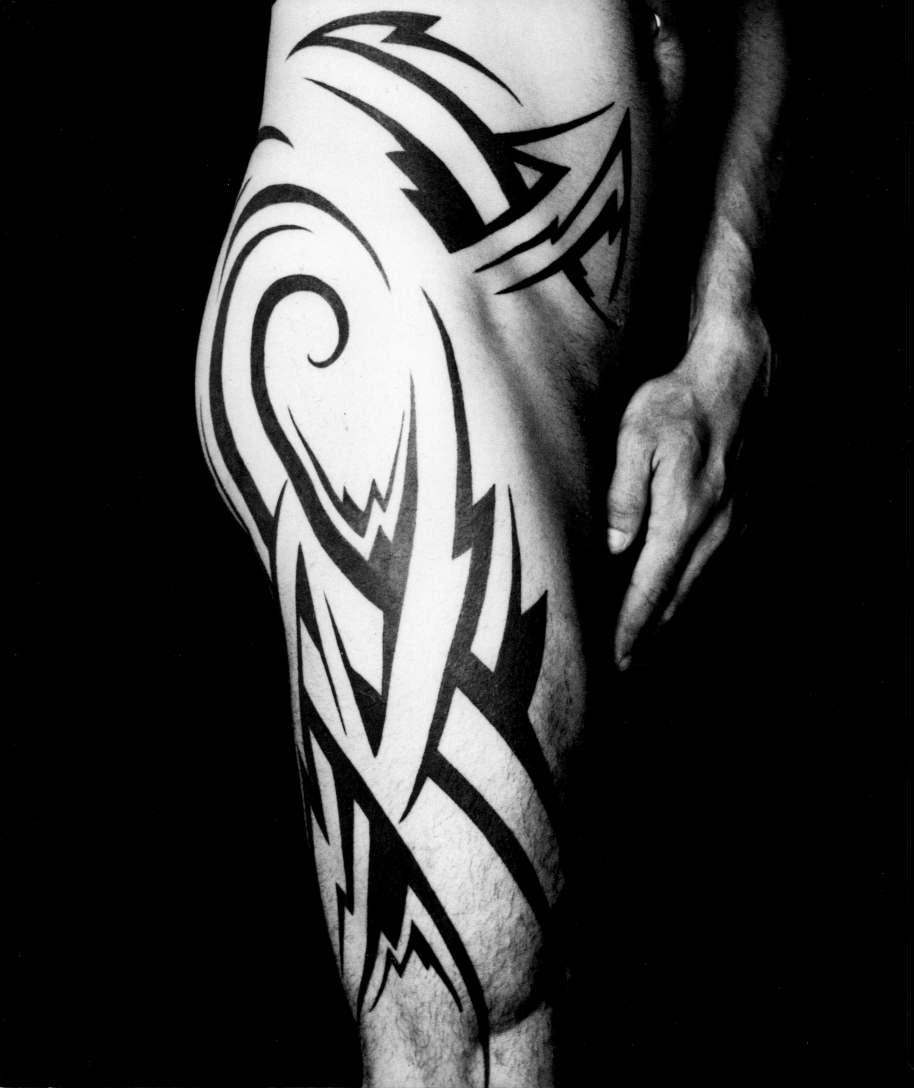

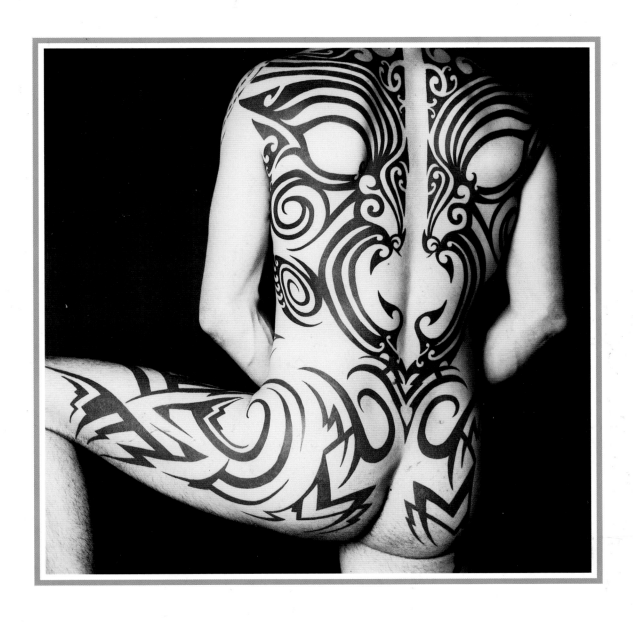

JILL JORDAN *(back and buttocks)*
ALEX BINNIE *(thighs)*

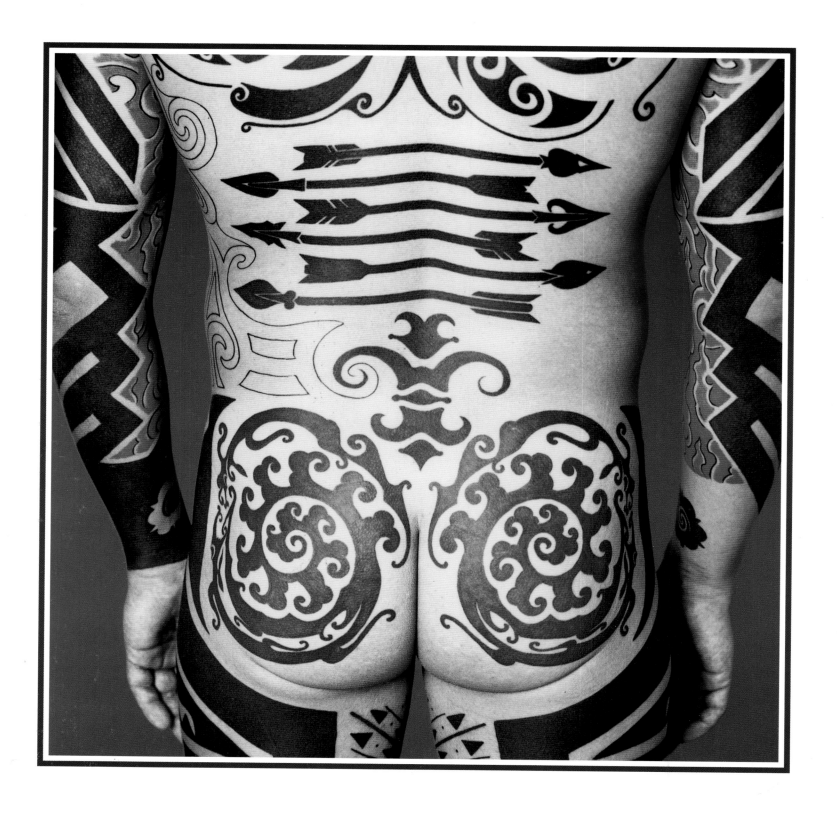

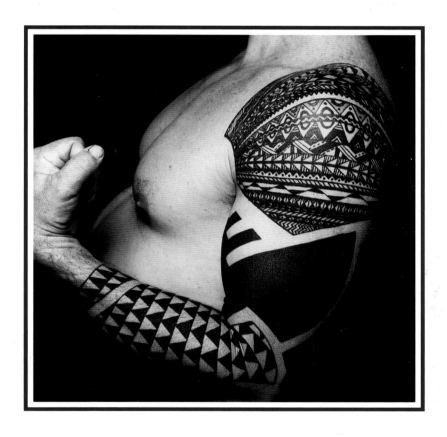

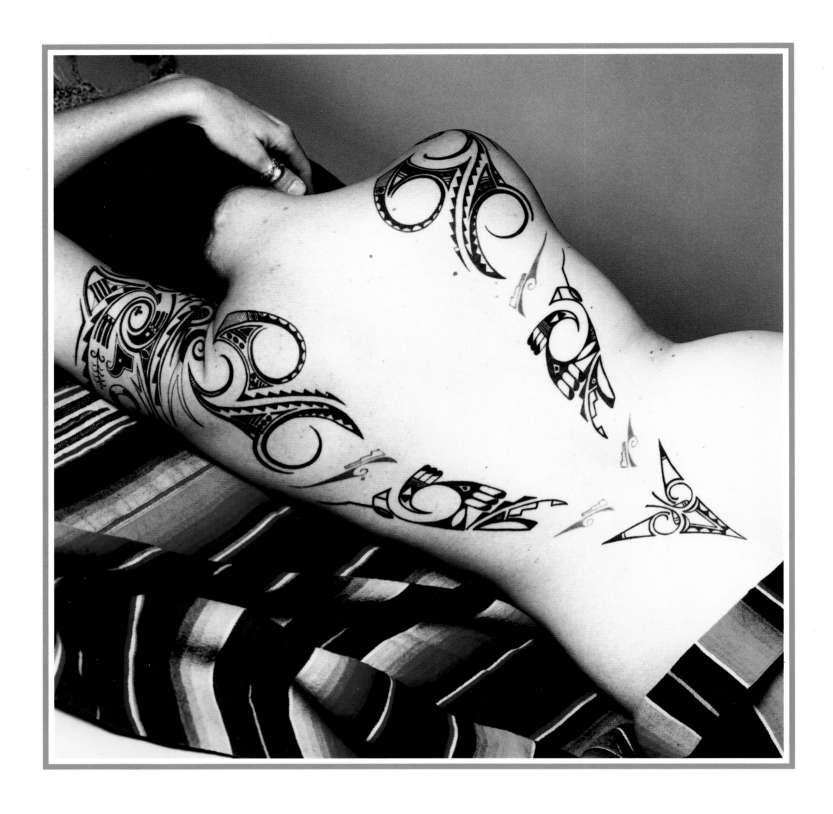

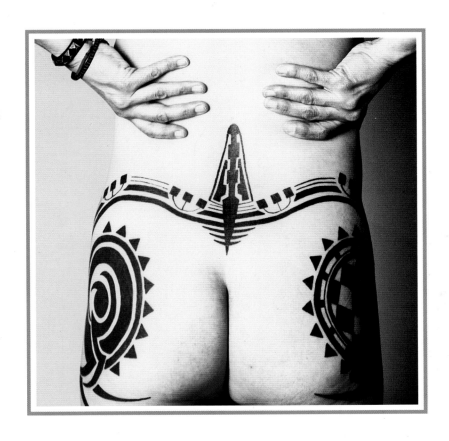

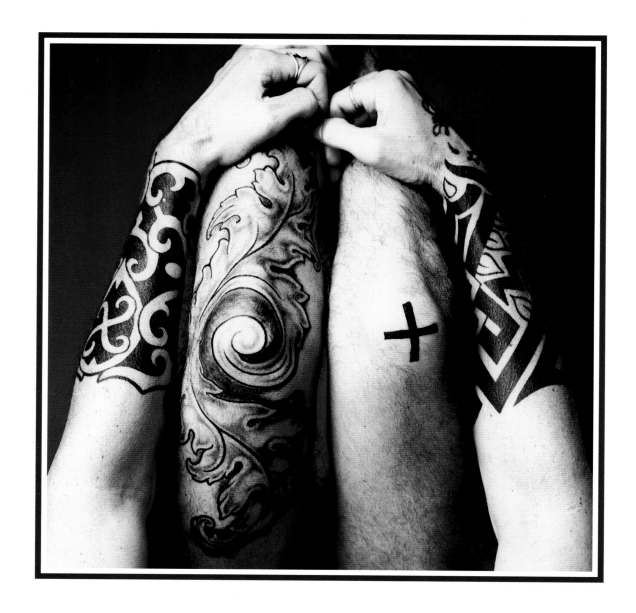

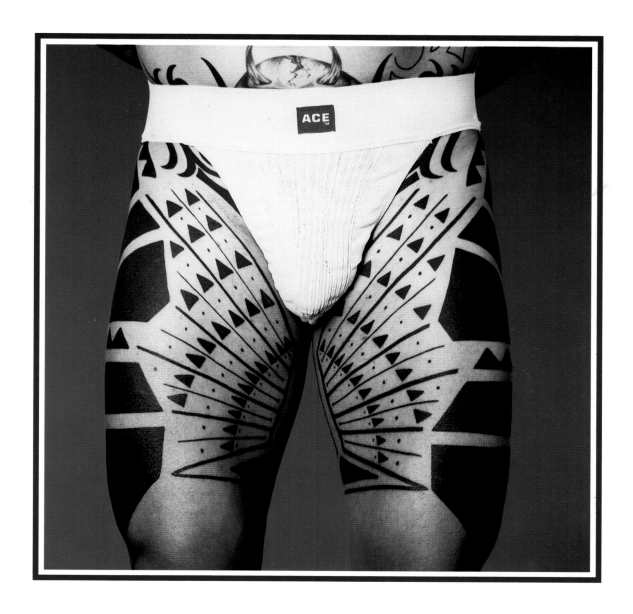

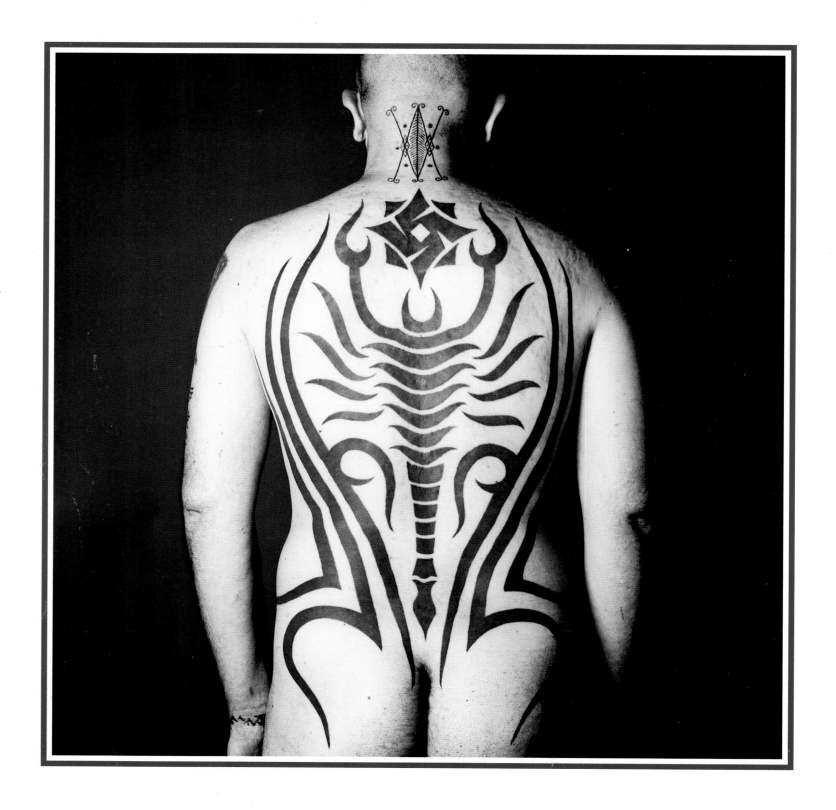

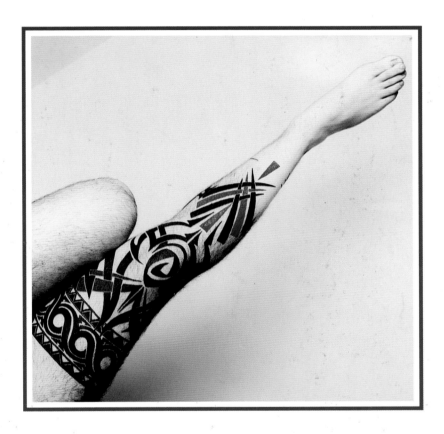

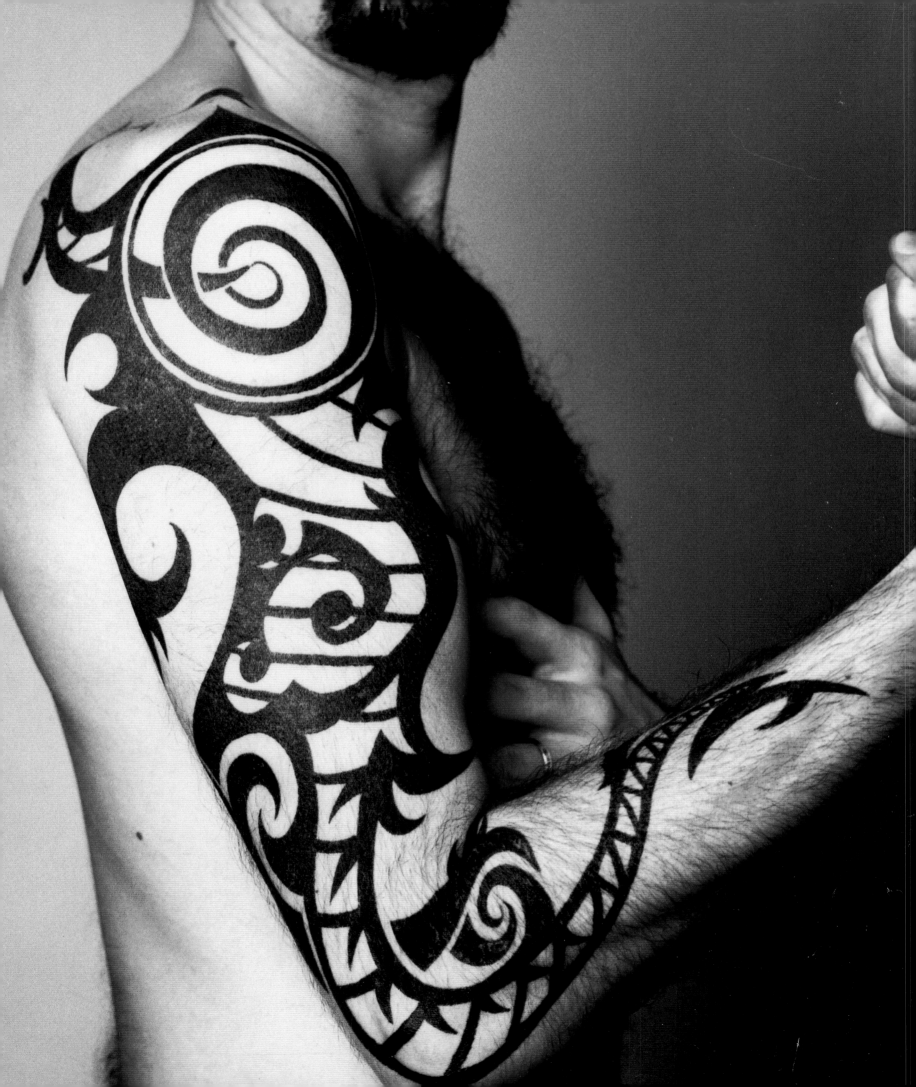

Opposite: LANCE LLOYD
ALEX BINNIE

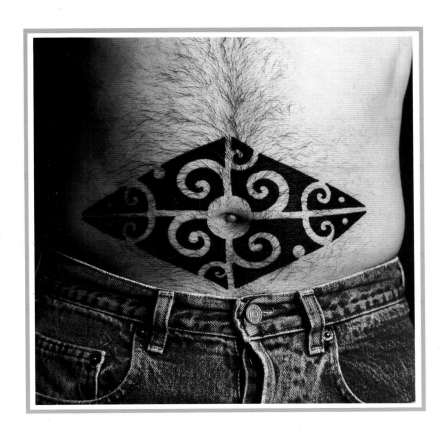

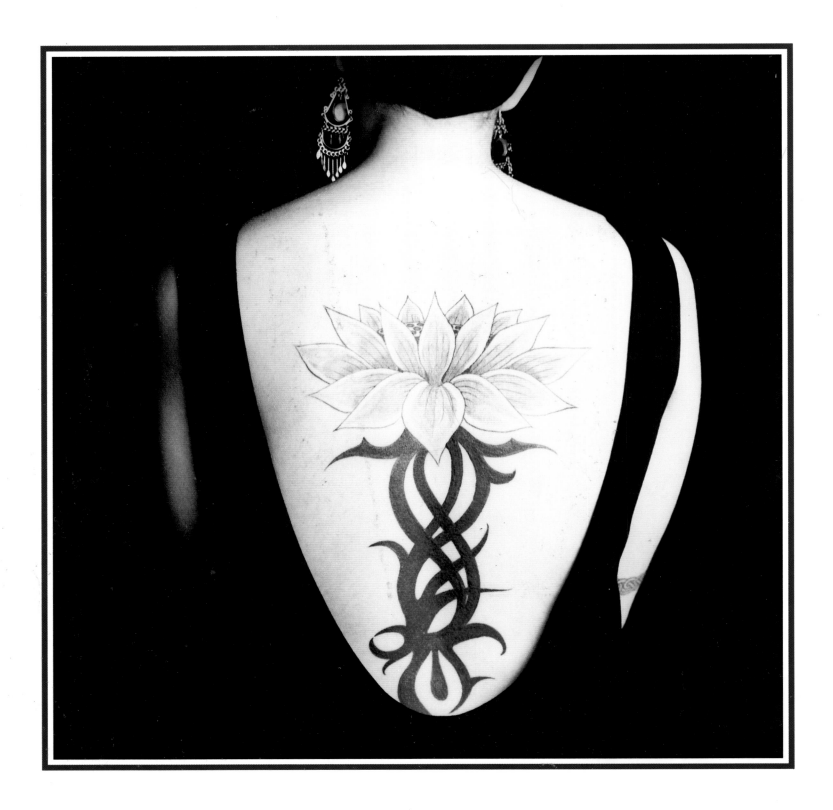

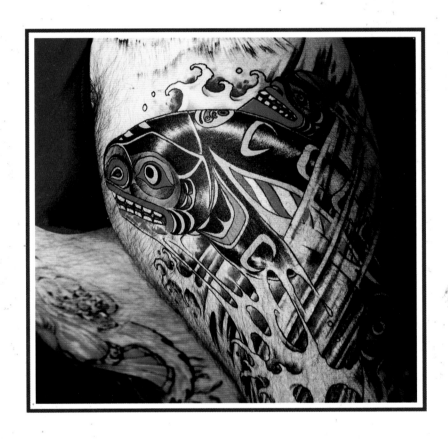

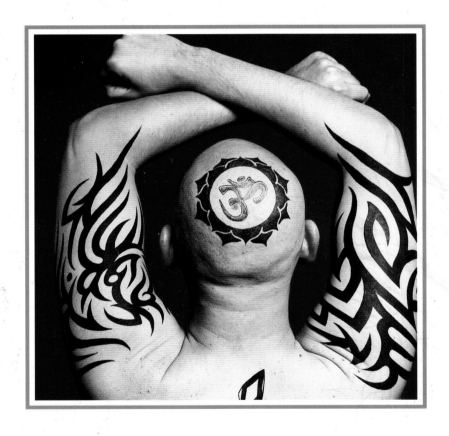

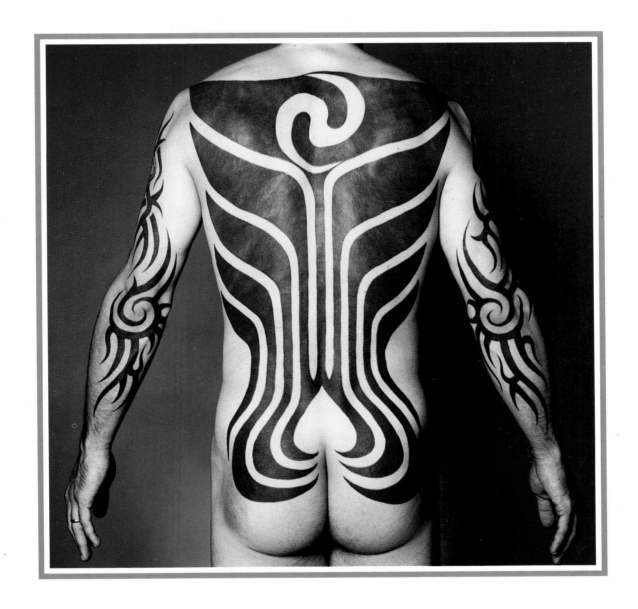

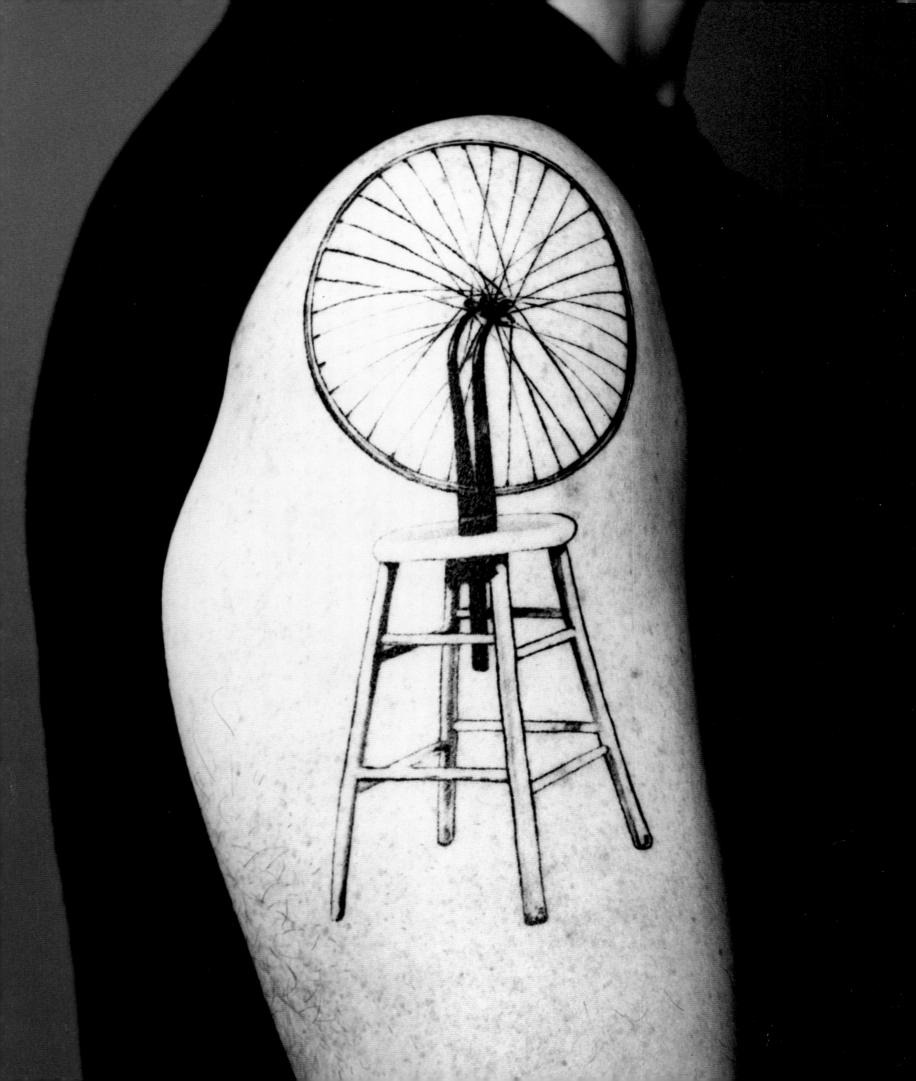

Paintings, Prints, and Portraits

Reproducing an artwork on someone's skin poses unique problems for a tattooist, who has to sublimate his or her own style in order to assume the role of an expert forger. Particularly if the subject is a well-known masterpiece, the success or failure of the appropriation will be immediately apparent, and it is much easier to hide errors in oil on canvas than in ink on skin. Nowadays tattooists have an unlimited palette of commercial colors from which to choose; one well-known supplier offers nearly ninety pre-mixed hues, including a dozen reds and as many blues, plus "electric" tones like hot pink and ultra-violet. Certain techniques can be especially difficult to imitate, like the chunky texture of an Edvard Munch woodblock (PAGE 51) or the soft ink washes of Japanese painting (PAGE 58).

One advantage to artistic appropriation is that alterations can be made at will, as in converting a three-dimensional Readymade sculpture by Marcel Duchamp into two-dimensional form (PAGE 42). The German artist Martin Schongauer surely never could have foreseen a Technicolor rendering on flesh of his fifteenth-century woodcut of Saint Michael slaying a dragon (PAGE 44). And a self-portrait by Vincent van Gogh has been interpreted in two very different ways: a fairly straightforward rendition (PAGE 47) and a fanciful medley with several of the artist's motifs (PAGE 46).

Other portraits, too, have captivated tattoo clients, who have transformed their limbs, backs, and torsos into quirky tributes. A tattooed portrait doesn't have to represent someone known to the bearer; it doesn't even have to represent someone real. One fellow's thigh is embellished with a dramatic rendering of Hamlet in the graveyard (PAGE 60), culled from illustrations and books on Shakespearean costumes. Another portrait appropriated from popular culture is the likeness of Salvador Dalí (PAGE 55) that caps a collection of several Dalí paintings accumulated on the epidermis of one of his admirers. And thanks to a guitar-magazine reproduction of an old concert poster, a musician realized his dream of sporting an homage to Jimi Hendrix (PAGE 61), set against an appropriately psychedelic background.

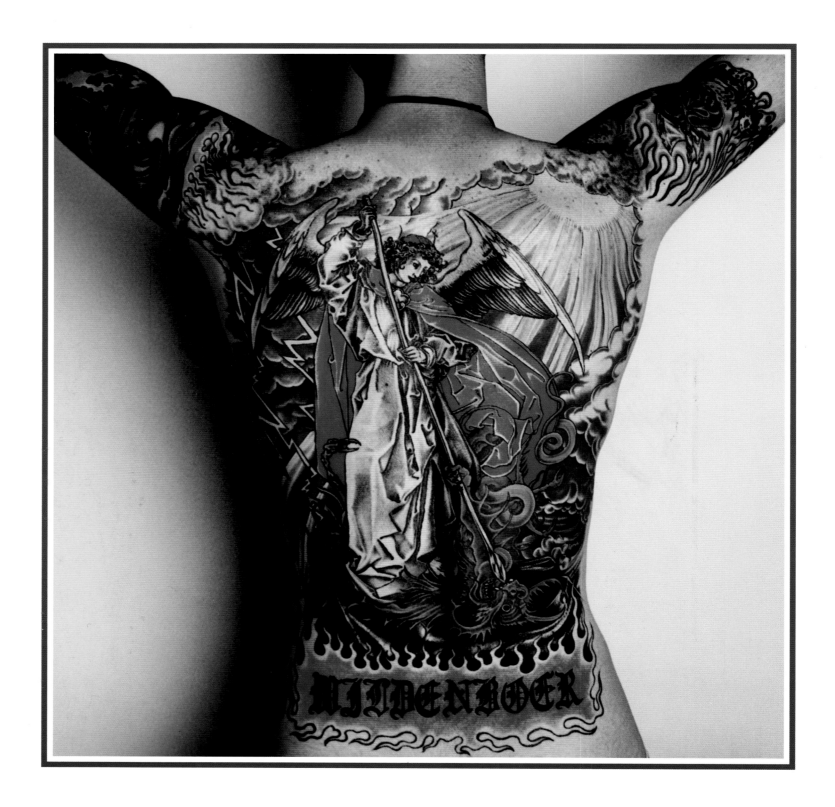

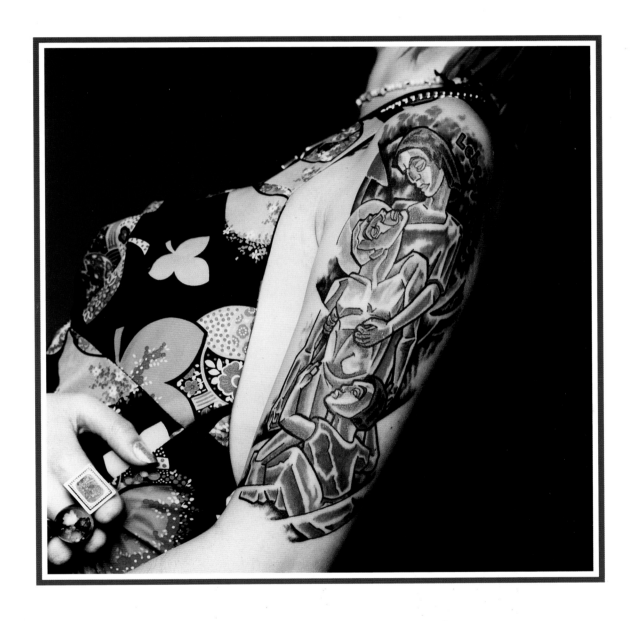

SUZANNE FAUSER *(van Gogh motifs)*
MR. MAX *(van Gogh self-portrait)*

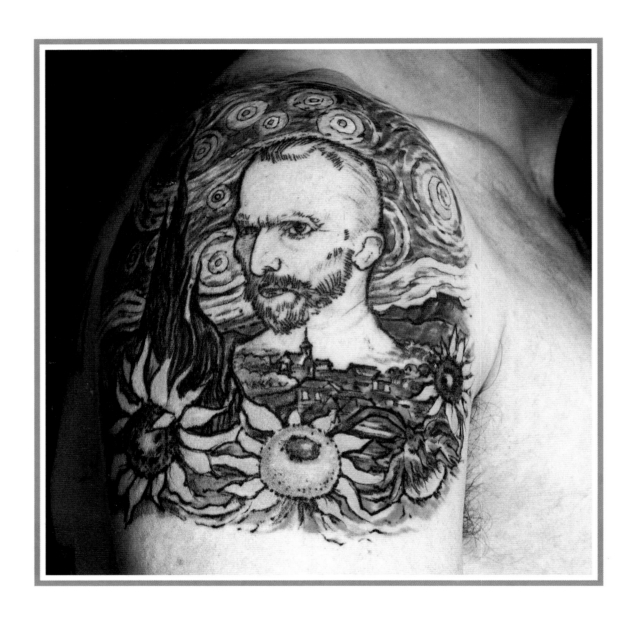

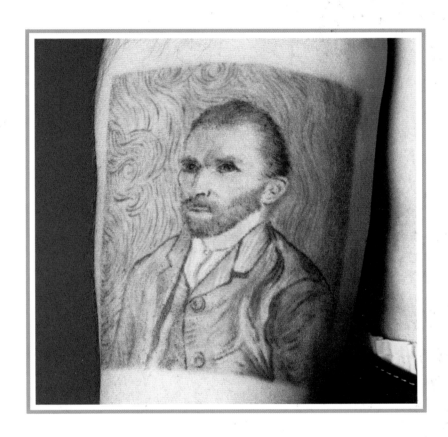

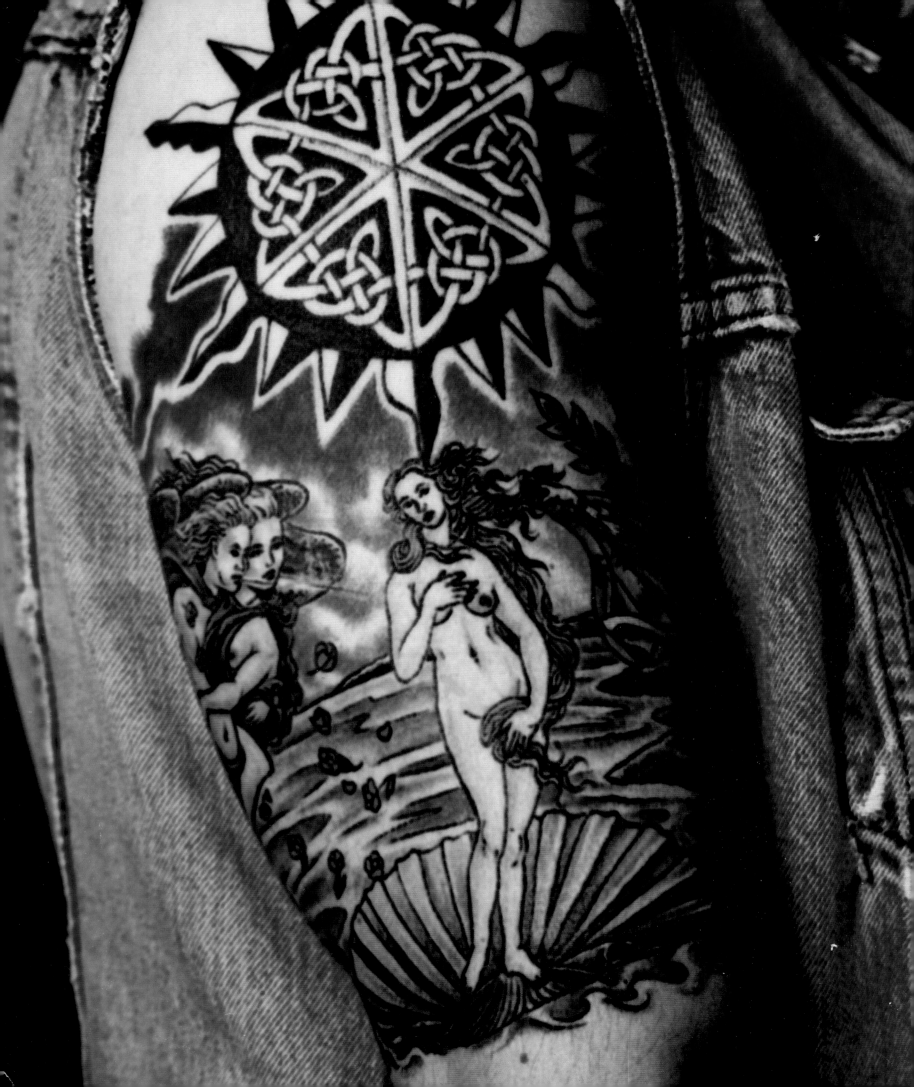

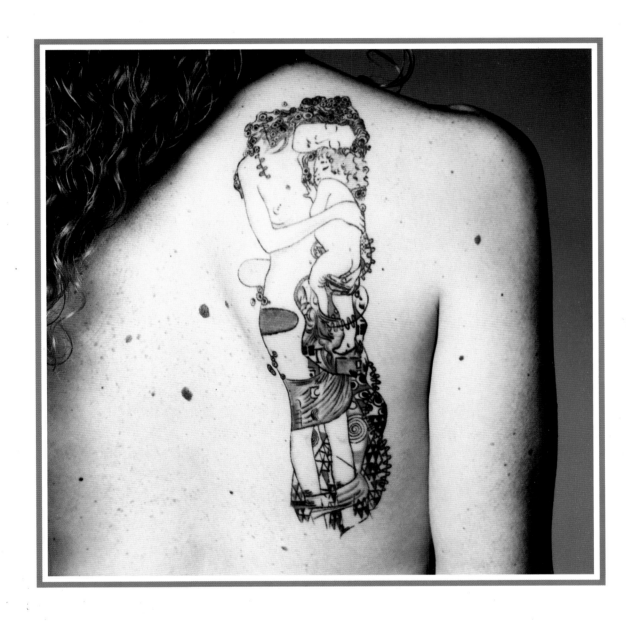

49

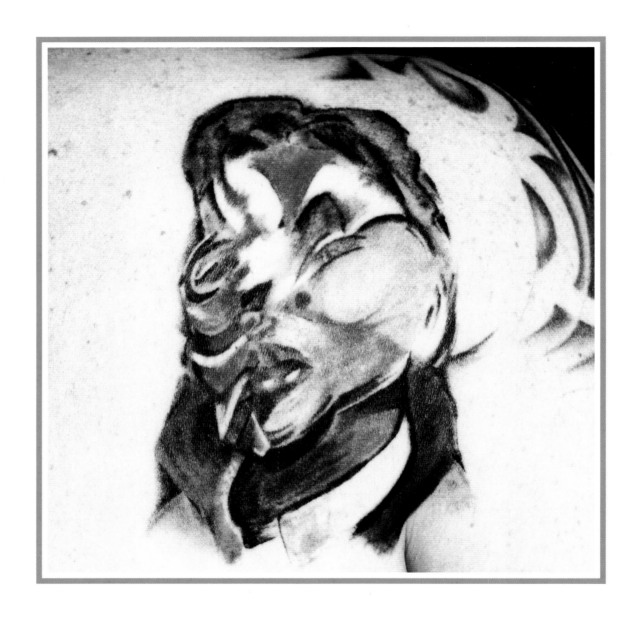

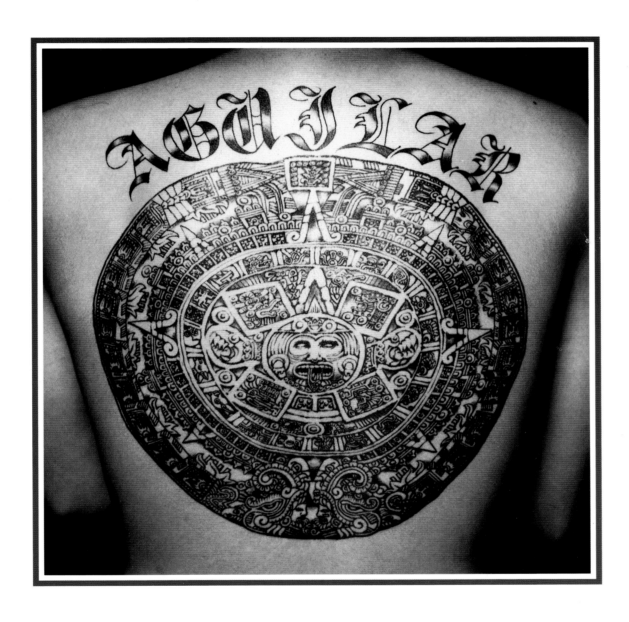

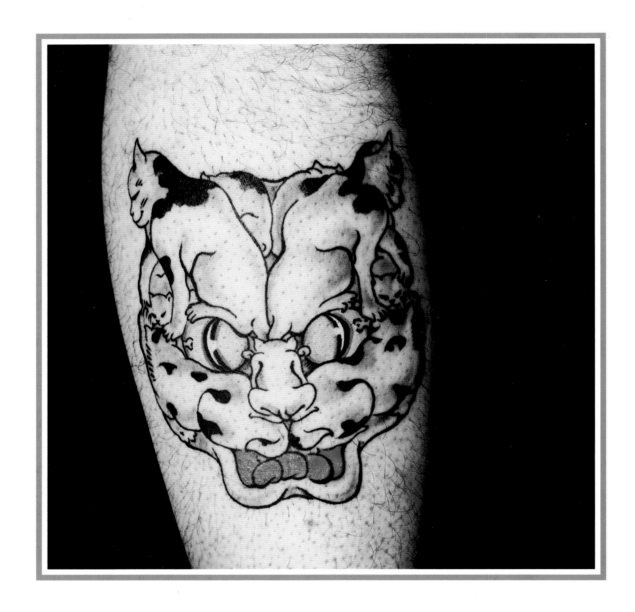

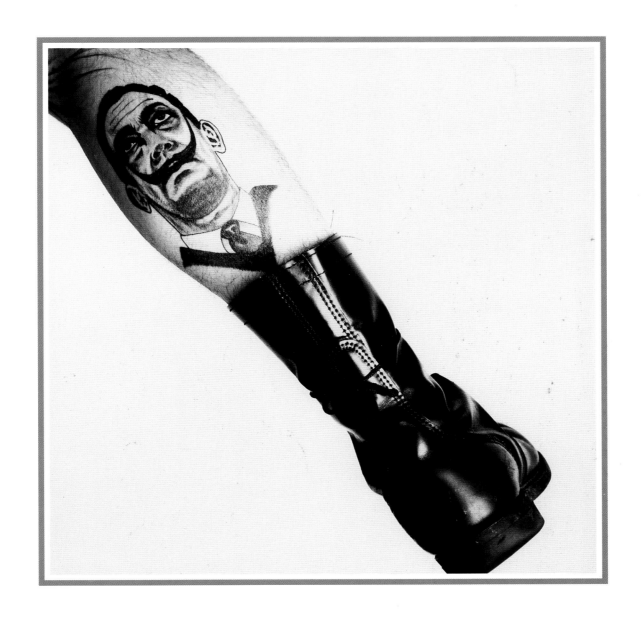

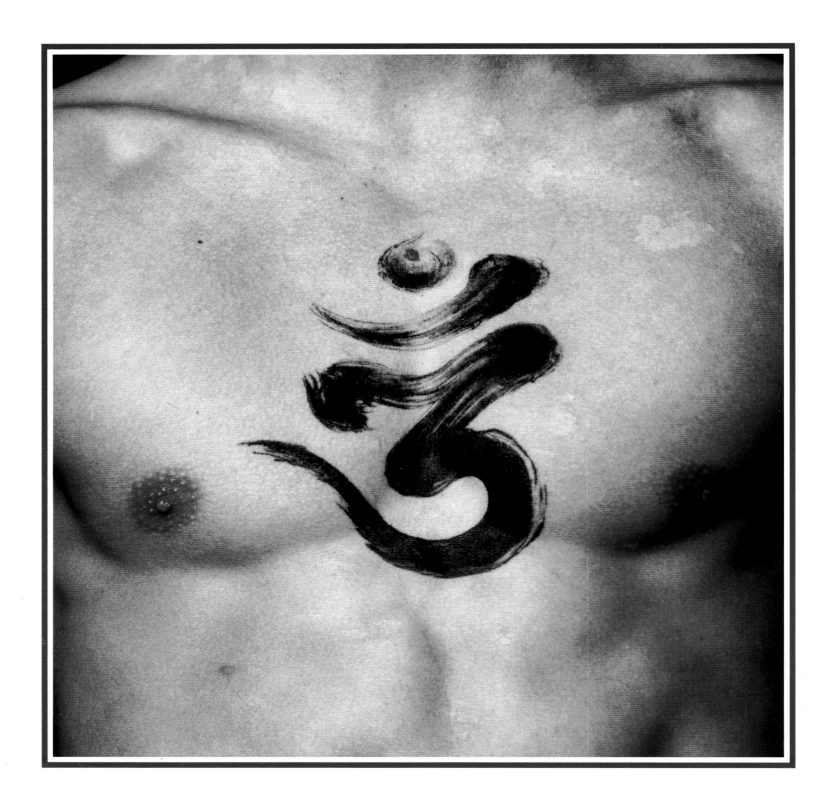

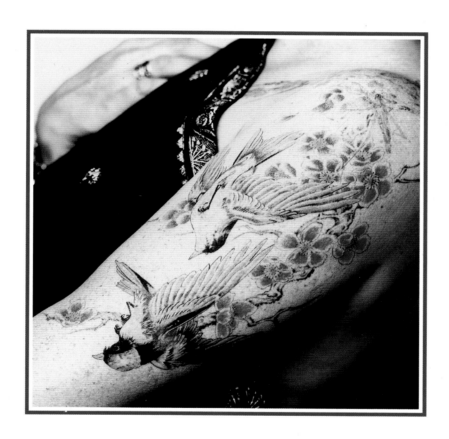

DANA BRUNSON *(solid birds on man)*
STEVEN MAST *(leaves and bird on woman's arm)*
ROBERT BENEDETTI *(birds on both chests)*

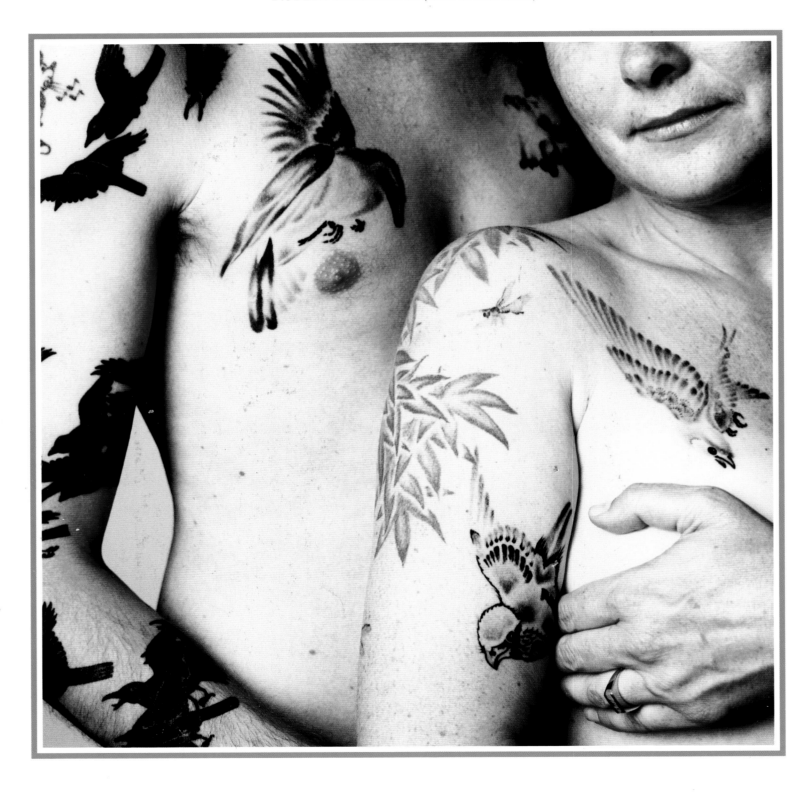

58

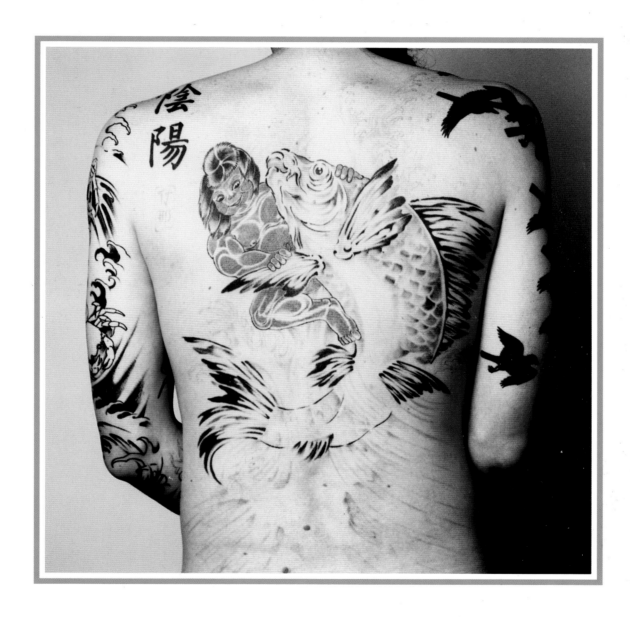

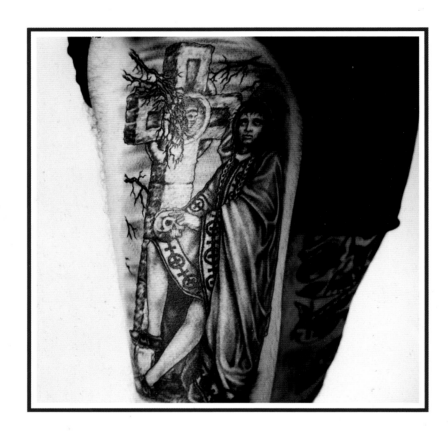

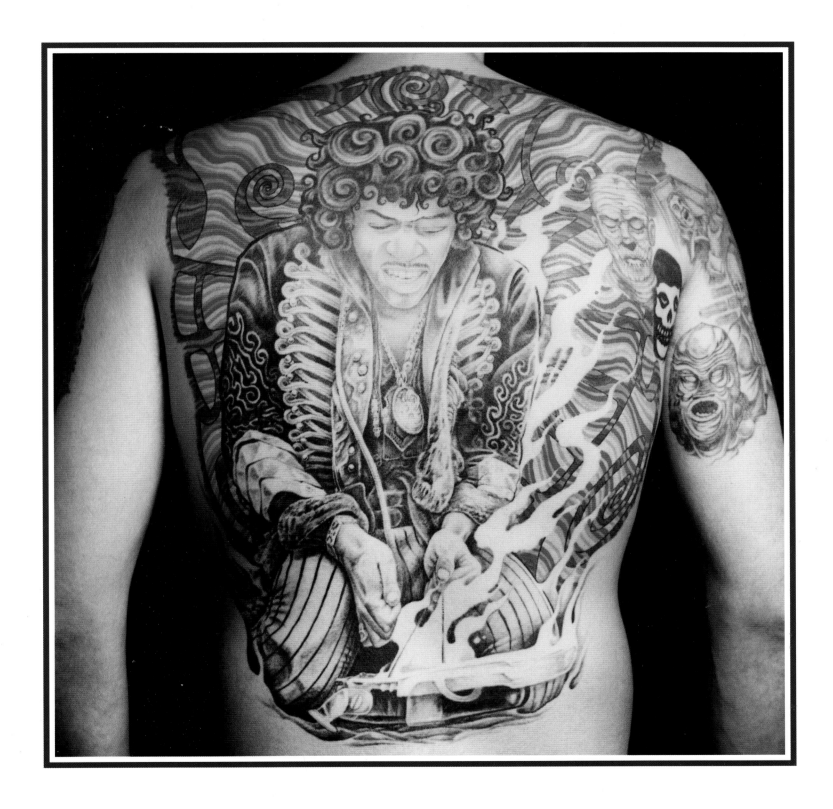

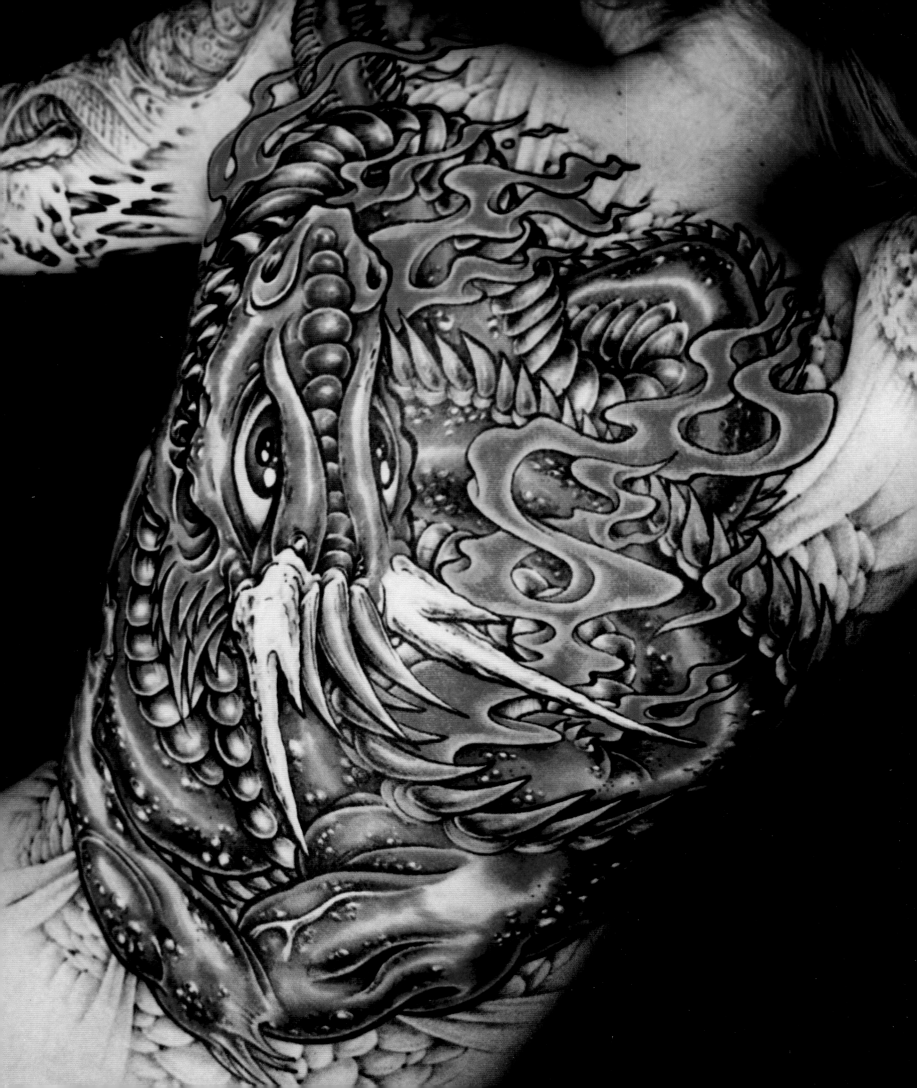

Imagination and Fantasy

The imagination is an ideal breeding ground for the new tattoo, with images from science fiction, dreams, nightmares, and even the more eccentric aspects of everyday life all becoming fodder for permanent icons. In tattoo parlance, *fantasy* often connotes a specific genre, one inspired by the wizards, gnomes, elves, and warriors popularized by games like Dungeons and Dragons and by illustrators like Frank Frazetta. But in my expanded definition, a fantasy tattoo can also take the form of the ancient Hindu god Shiva (alternatively depicted as male or female), who was subjected to a modern makeover for a tattooed carpenter: the traditional drum, flute, flame, and snake have been replaced by, among other things, a screwdriver and an electric drill (PAGE 75). Alterations of scale, too, can yield major fantasy statements, as with a pair of vibrant butterfly wings that, when enlarged to human proportion, give an angelic—and surreal—aspect to a woman's back (PAGE 72).

Inspiration for these inventive images can be commandeered from disparate sources. An Italian cathedral ceiling or a diminutive greeting card might have influenced the pair of Baroque putti that seem to burst from one woman's abdomen, but whatever the source, they have been thoroughly transformed by the tattoo artist's distinctive personal style (PAGE 73). Even a simple, unmodulated line drawing—that of a woman cavorting with a playful yam (PAGE 74)—makes for good fantasy material, inspired by a decades-old newspaper advertisement for a record.

Surf, turf, and the extraterrestrial domain can all be mined for imaginative tattoos. An elaborate undersea kingdom complete with mer-couple and treasure chest transforms a man's torso into an aquatic dream (PAGE 68). A doctor's back becomes a gateway to a kaleidoscopic world collaged from fact and fantasy: a Persian goddess holds court among swirling fractals (popularized by Chaos theory) and earthbound onion domes (PAGE 71). And biomechanical, sci-fi scenes recalling illustrations by H. R. Giger are particularly popular, often reflecting a dark vision of a distinctly monstrous future (PAGE 70).

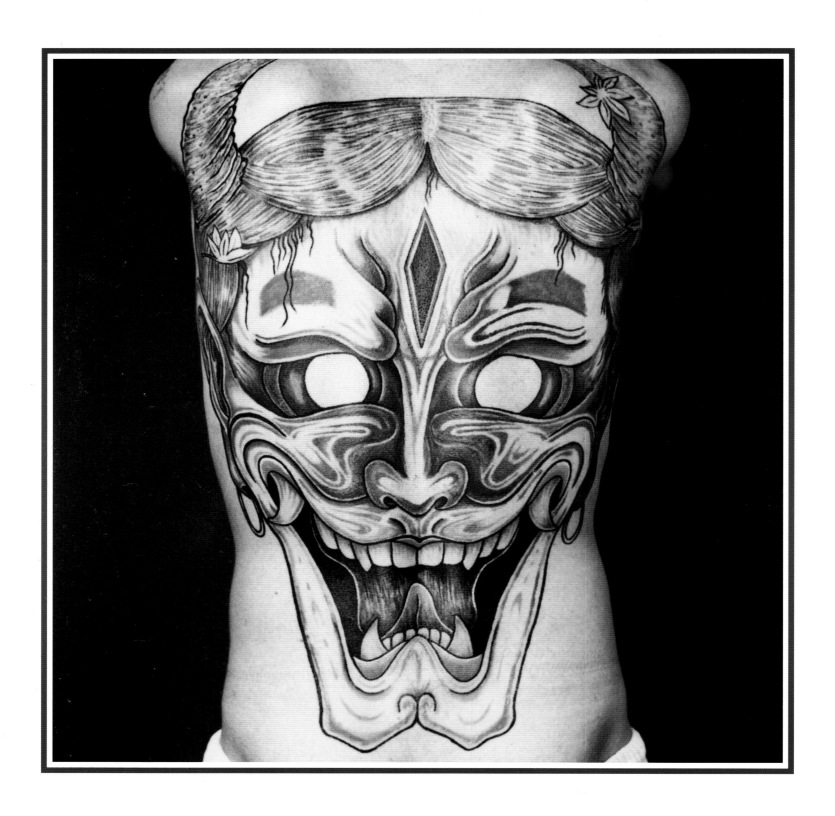

MARCUS PACHECO *(color work)*
AARON CAIN *(black geometry)*

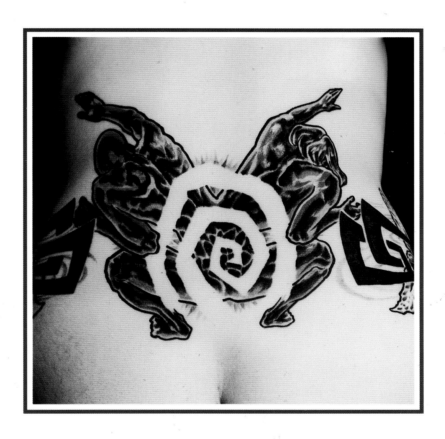

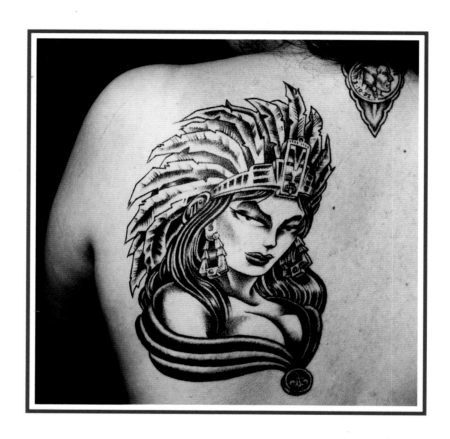

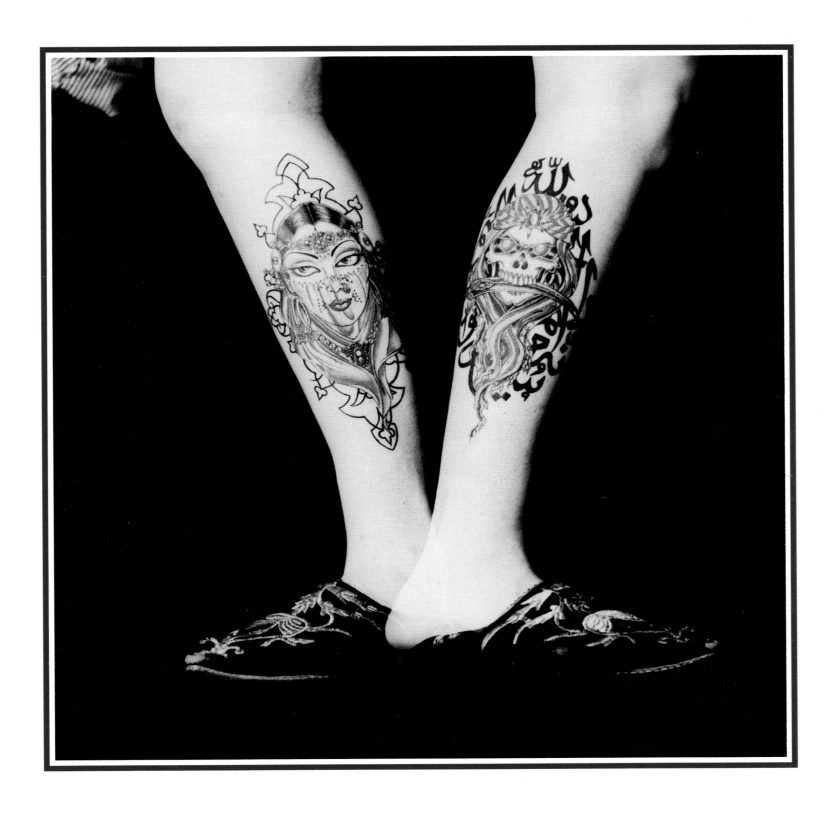

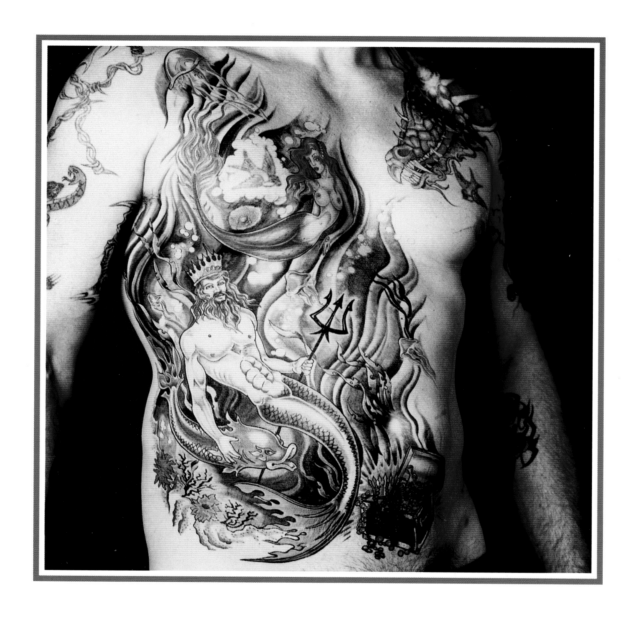

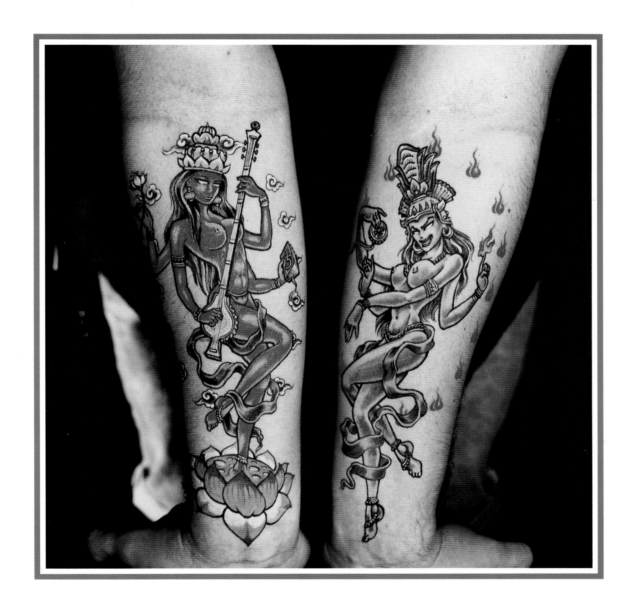

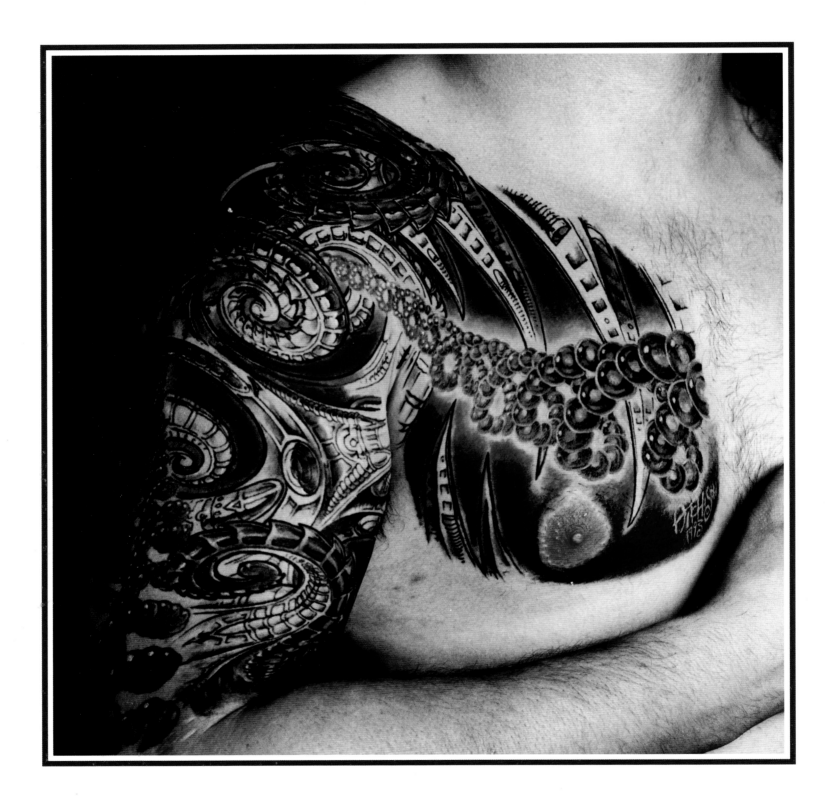

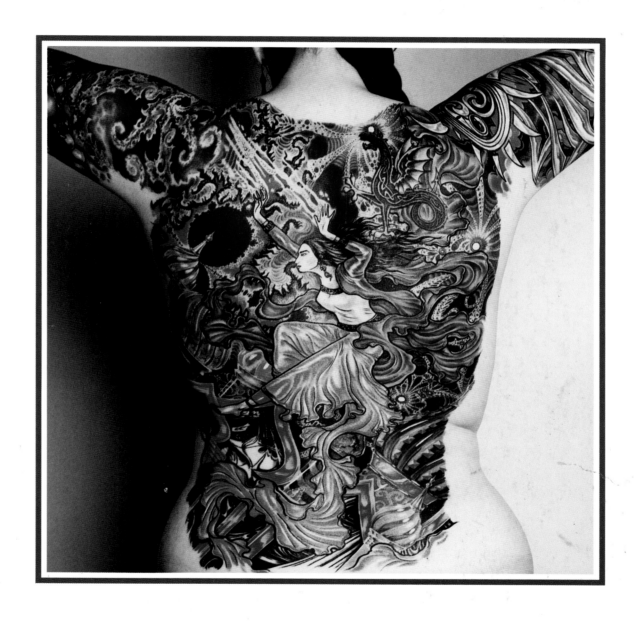

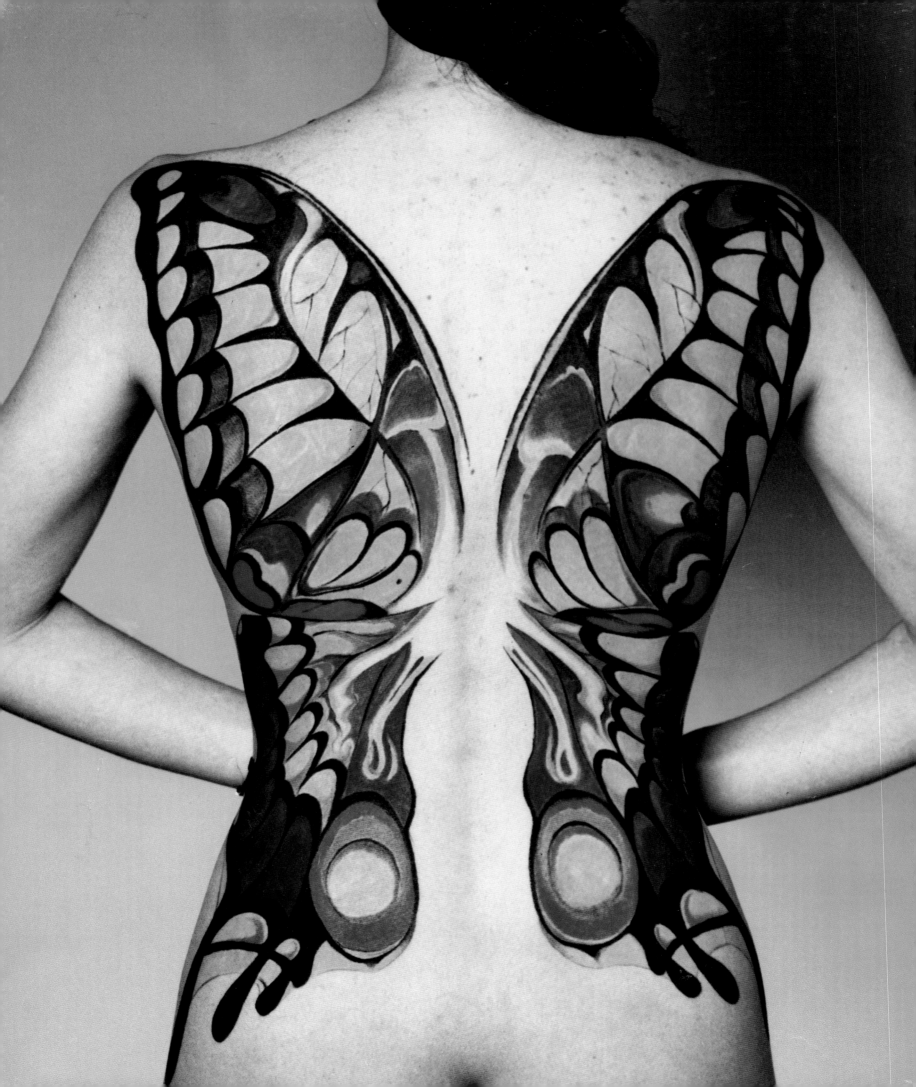

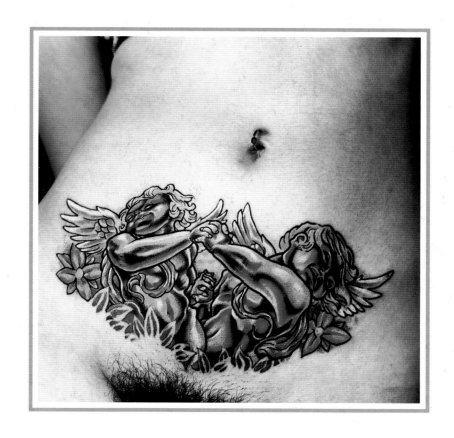

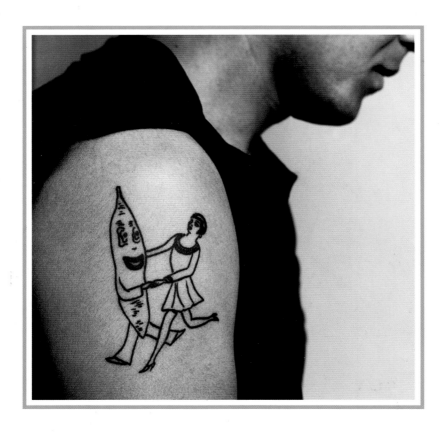

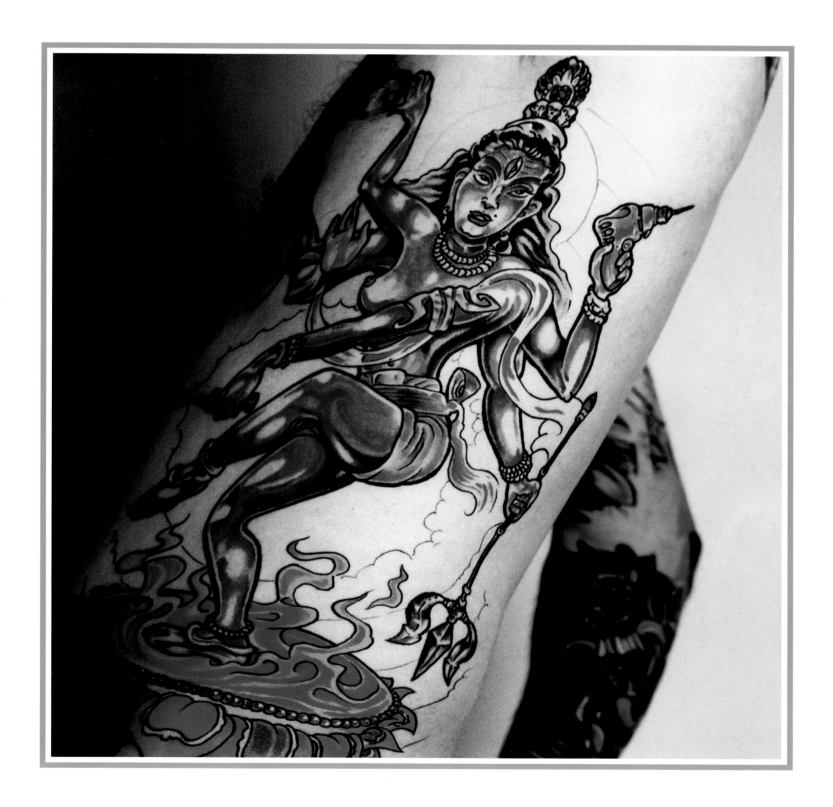

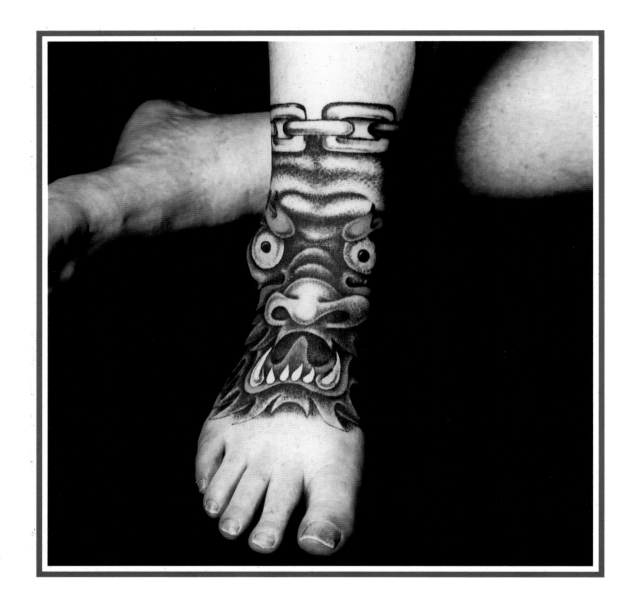

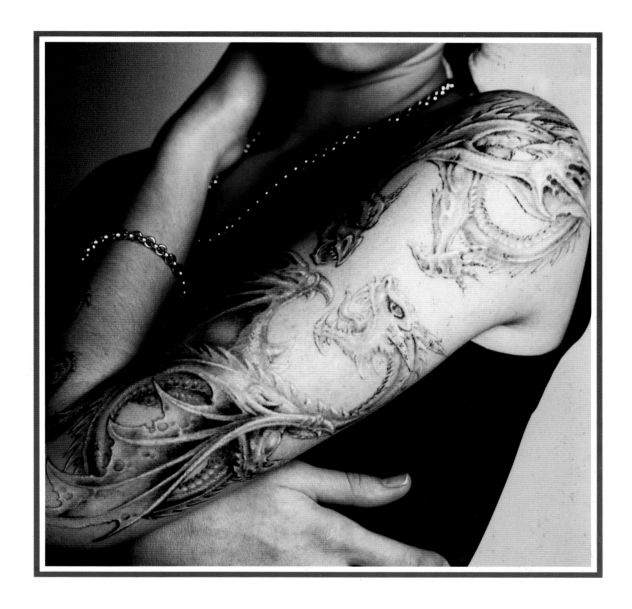

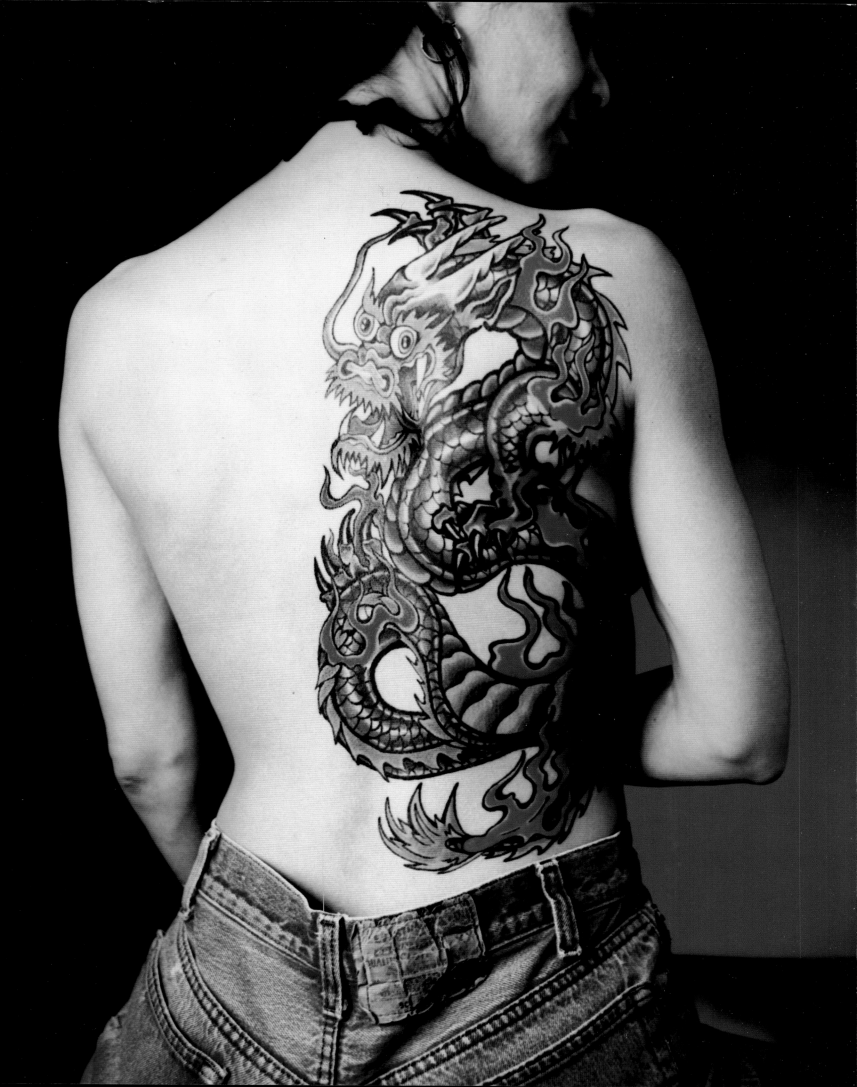

Neotraditional

Traditional Japanese and traditional American tattoos are at opposite ends of the stylistic spectrum, but they have both maintained their popularity among artists and patrons. In fact, classic American tattoos are enjoying renewed interest at the moment, with designs that recall earlier twentieth-century styles being very much in demand (PAGES 88 and 89). But unlike their predecessors, tattoo artists today—whether working with traditional Japanese or classic American motifs—have the potential for much greater versatility than in the past, thanks to newly available colors and the freedom to experiment with variations in line, shading, and imagery.

The result of all the cross-fertilization and technological development is that traditional images are frequently updated to look entirely contemporary. For instance, one ever-popular motif, the Sacred Heart—with its flaming cross and circle of thorns—packs a decidedly untraditional wallop when it is rendered in pulsating color against a whirling vortex (PAGE 93) or oddly encircled by teeth (PAGE 82). Even the revered Rock of Ages, popular as a flash design since early in the century, seems to hover in a realm between then and now, with traditional strong lines, silhouettes, and shading juxtaposed against a vividly luminous sky that could not have been achieved fifty years ago (PAGE 85). Conversely, what appears to be a convincingly "old school" tattoo might actually be a new design that simply recalls the classic style. The bold outlines and reduced palette of a distinctive armband hark back to the bygone days of tattooing, although the custom design is thoroughly new (PAGE 84).

Japanese-style tattoos have undergone the same evolution in America, where tattooists may find inspiration in the centuries-old themes or in the Japanese approach to tattoo placement. Thus, a tattoo may look Japanese because it incorporates traditional elements like cloud bars, dragons, snakes, flowers, or goldfish (PAGES 19 and 87). Or it can have a traditional Japanese effect due to the way it is fully integrated with the body—for example, arm-encircling sleeves may extend in traditional fashion to the breast but may or may not use any other Japanese components (PAGES 80 and 81).

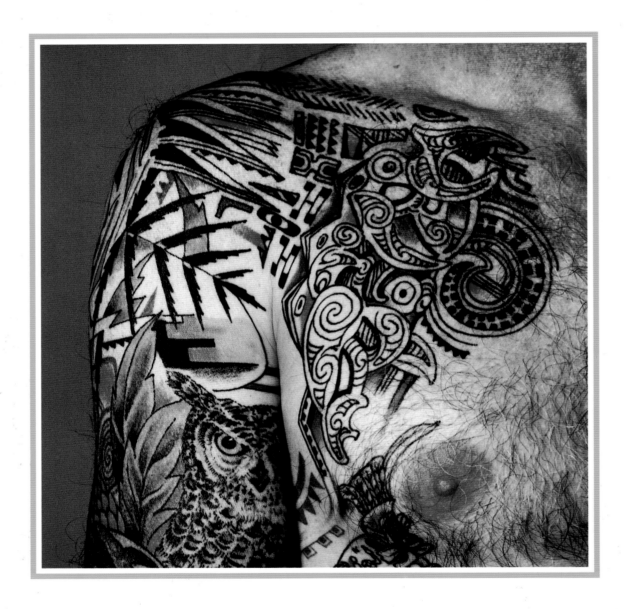

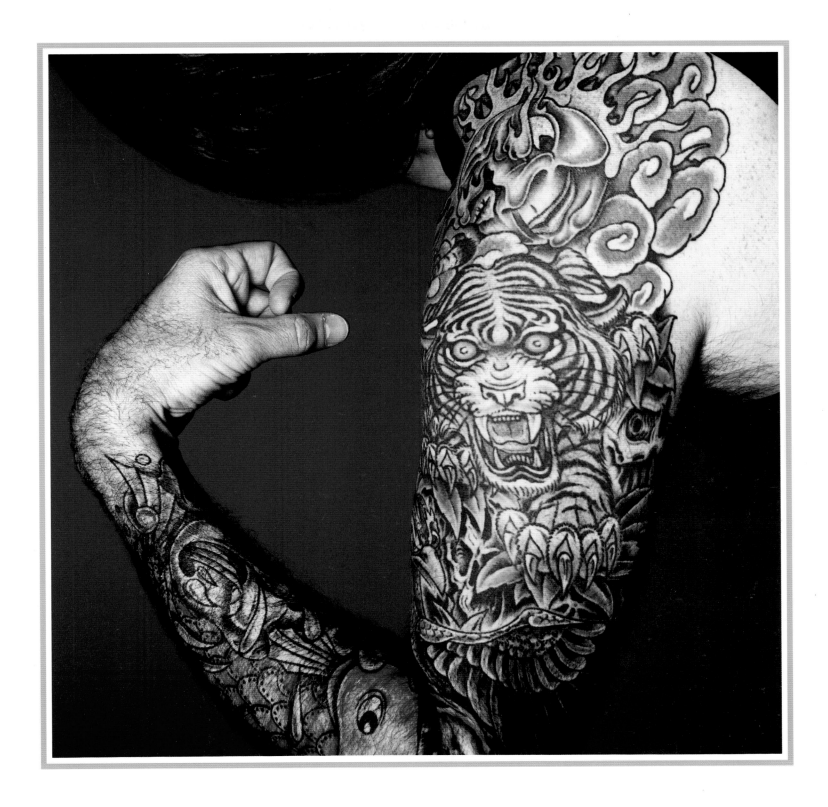

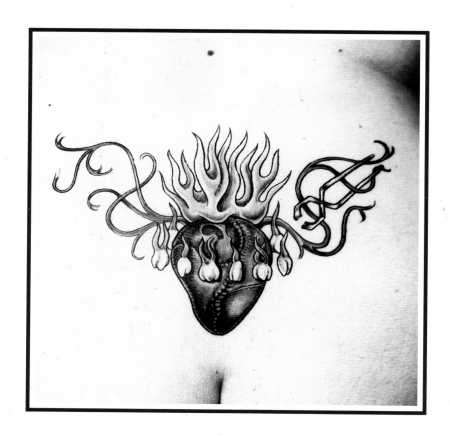

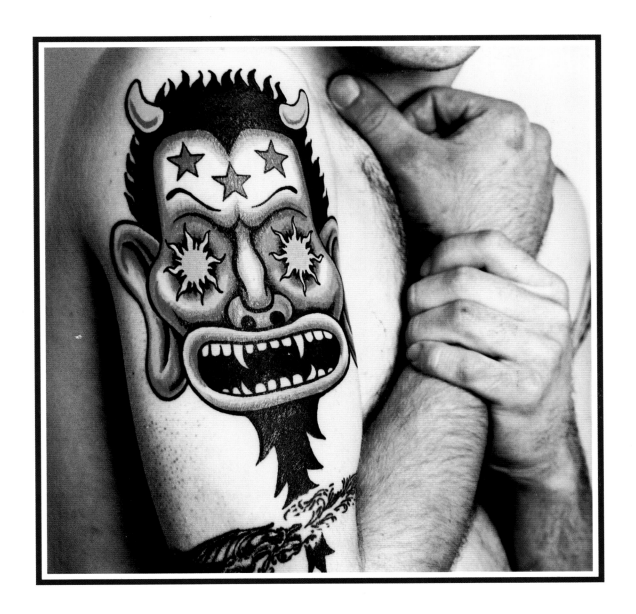

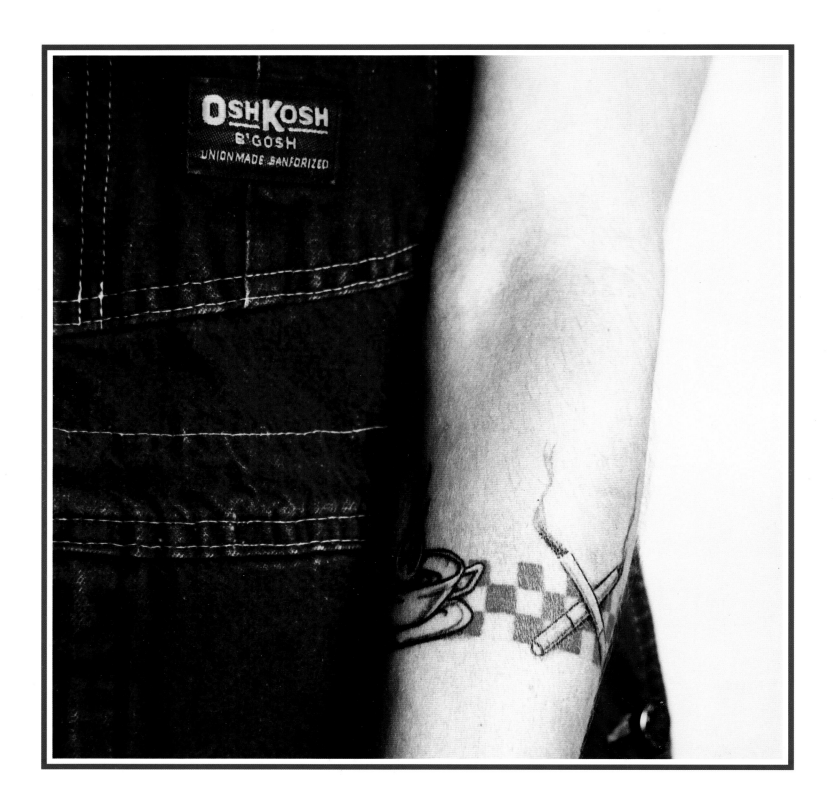

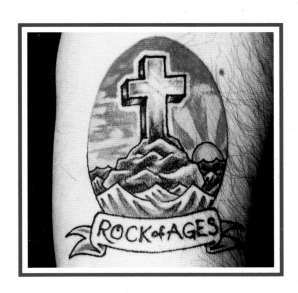

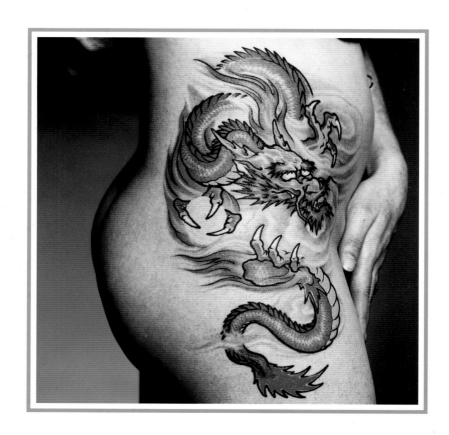

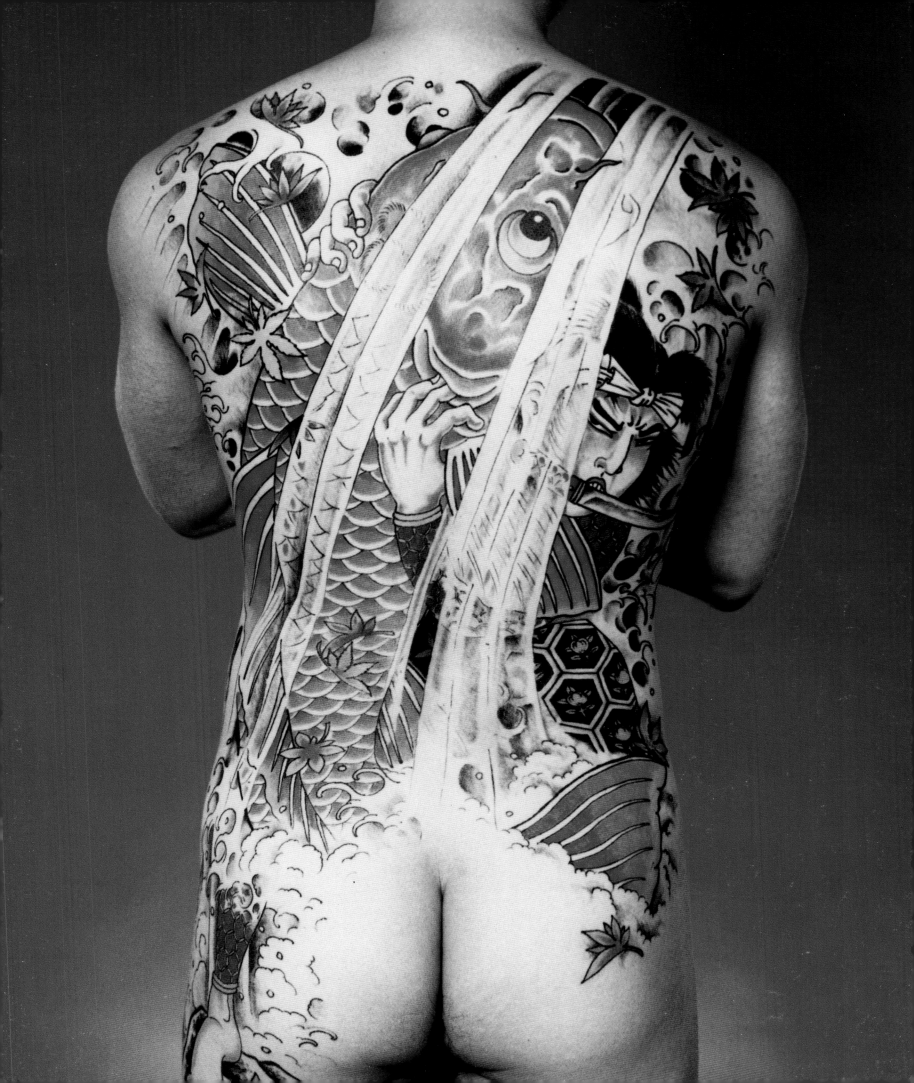

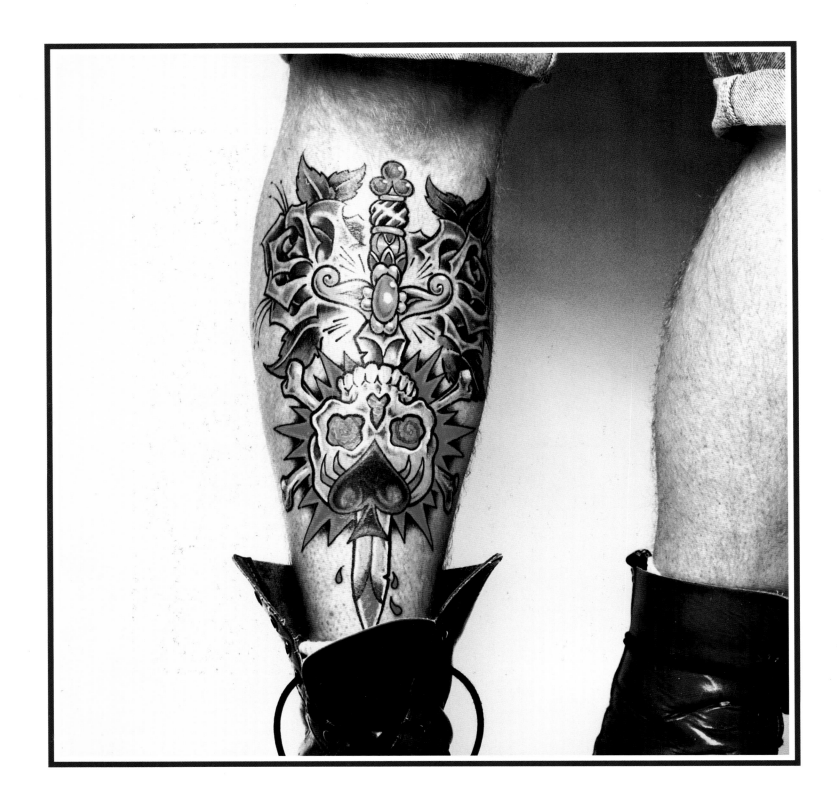

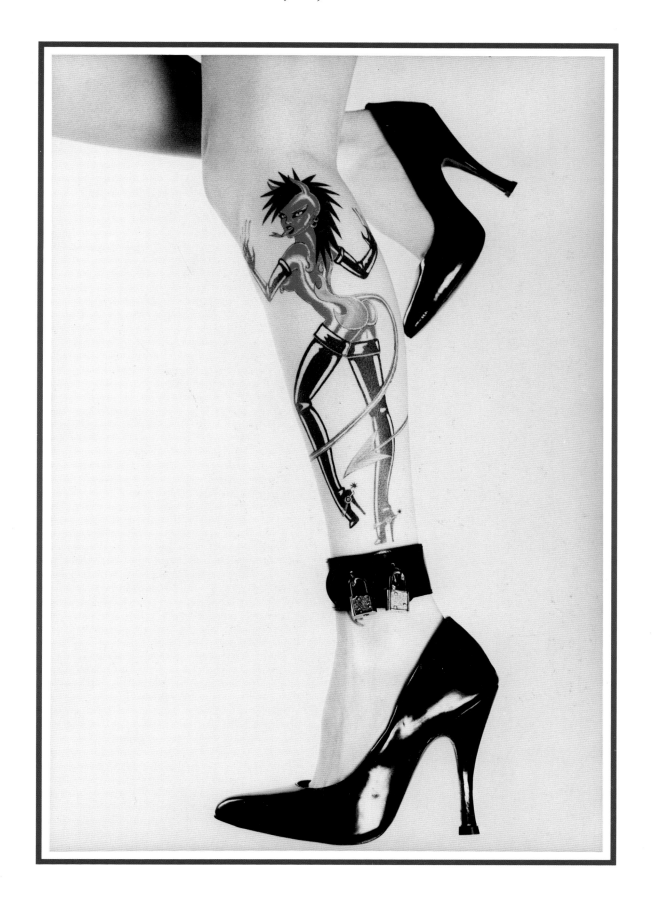

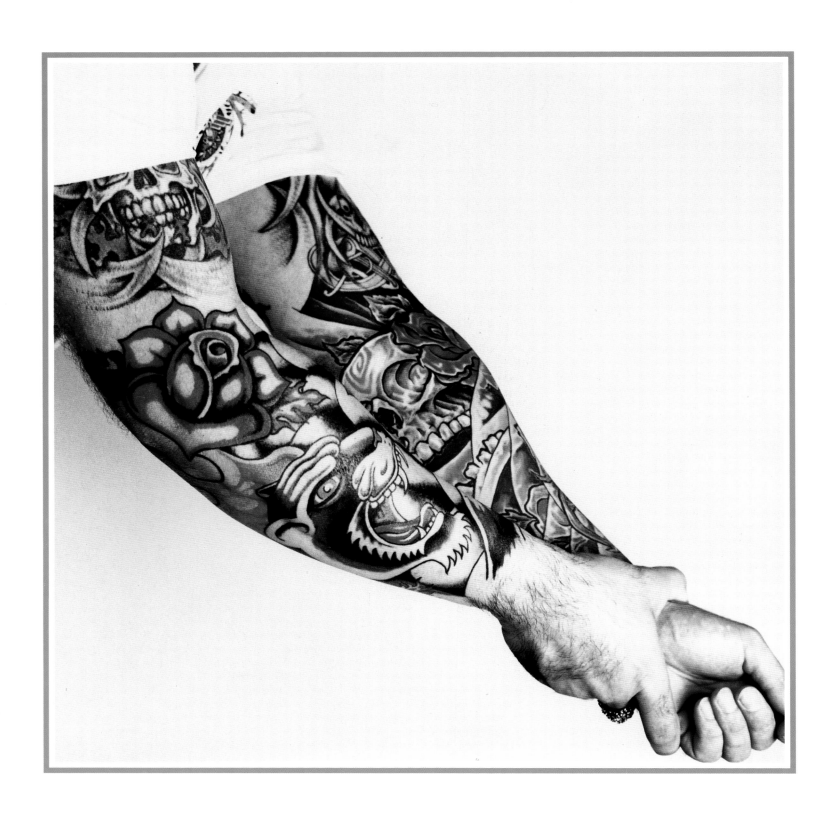

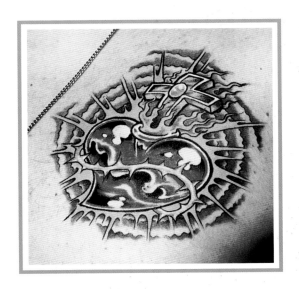

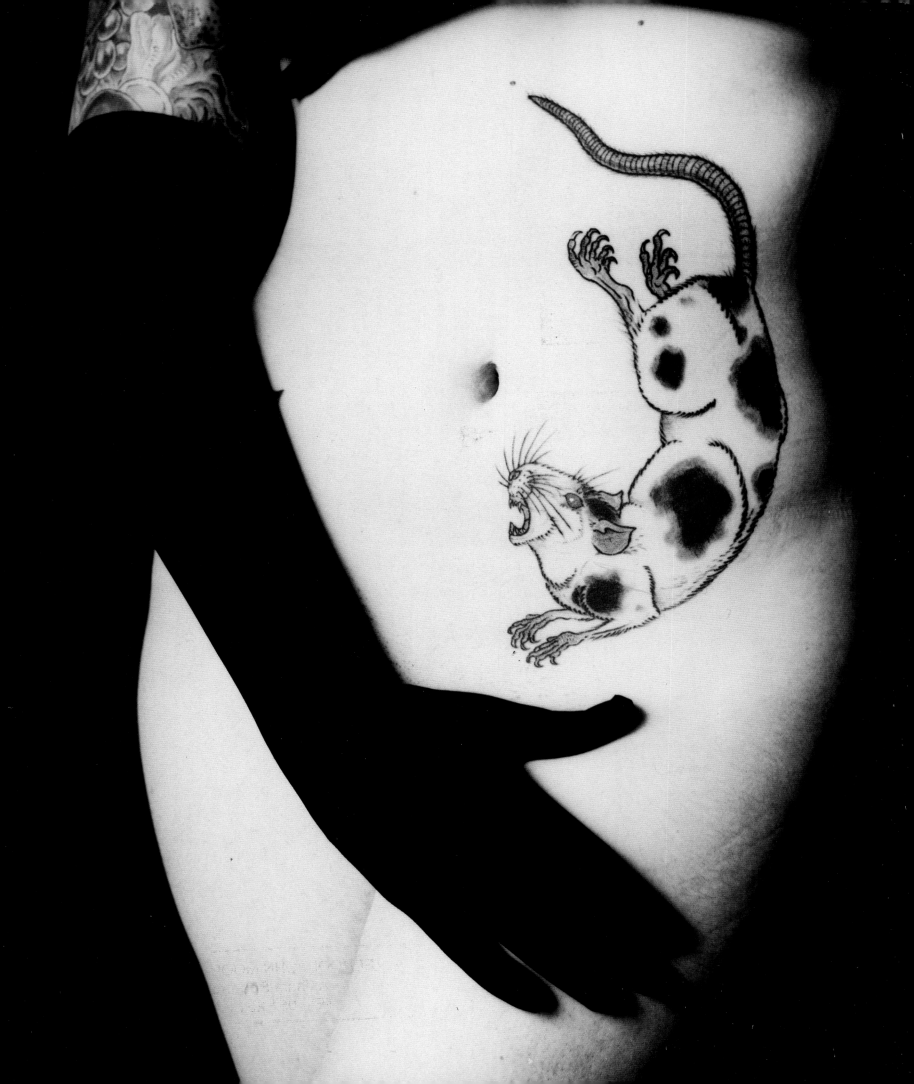

All the Rest

There are potentially as many categories as there are individual tattoos, and in the long run defini-tions are more arbitrary than useful. What counts is the result, not the category. Many tattoos defy neat labeling, so this catchall chapter includes everything from a food label to a grapevine, a rat to a calla lily.

Once again, the stylistic approaches are as varied as the tattoos themselves. One extremely dense, stained-glass-like arm piece, commissioned by a filmmaker, shows the fragmented innards of a video camera (PAGE 108). Visually and conceptually, it is in marked contrast to the minimalist black wedge that adds a certain enigmatic intensity to a laboratory technician's forearm (PAGE 111). Even using just the reduced elements of pure line and flat black ink, tattoo artists create a mind-boggling array of designs, whether a bold geometric pattern (PAGE 110) or delicate Art Nouveau tracery (PAGE 100).

Other tattoos are more elaborately executed. A bejeweled bracelet makes an impressive, and enduring, bauble for a hairdresser (PAGE 104), while a gleaming crown seems to signify a permanent chessboard victory (PAGE 105). The intricate exoskeleton of a sea horse is reproduced with awesome clarity (PAGE 2), while the flowing outlines of an exotic bird are poetically suggested rather than solidly filled in (PAGE 112). A more cartoonish rendering of fruit-eating crows is as accomplished as it is entertaining (PAGE 113).

Ritualistic emblems, religious symbols, and personal totems with meanings only to their owners appear frequently as tattoos, offering protection and solace. Stylized Tibetan flames (PAGE 103) and Native American ceremonial objects (PAGE 96) proclaim respect for two different creeds. Repe-tition of the number seven (PAGE 114) in a heart and on a pair of dice might proclaim belief in—or at least allegiance to—Lady Luck.

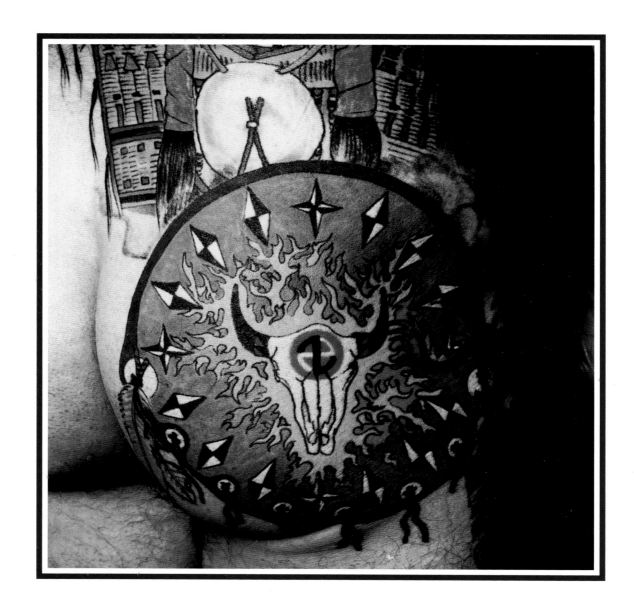

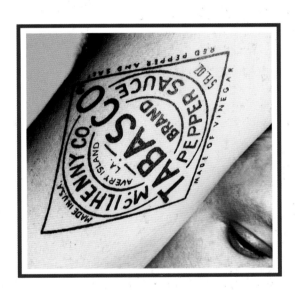

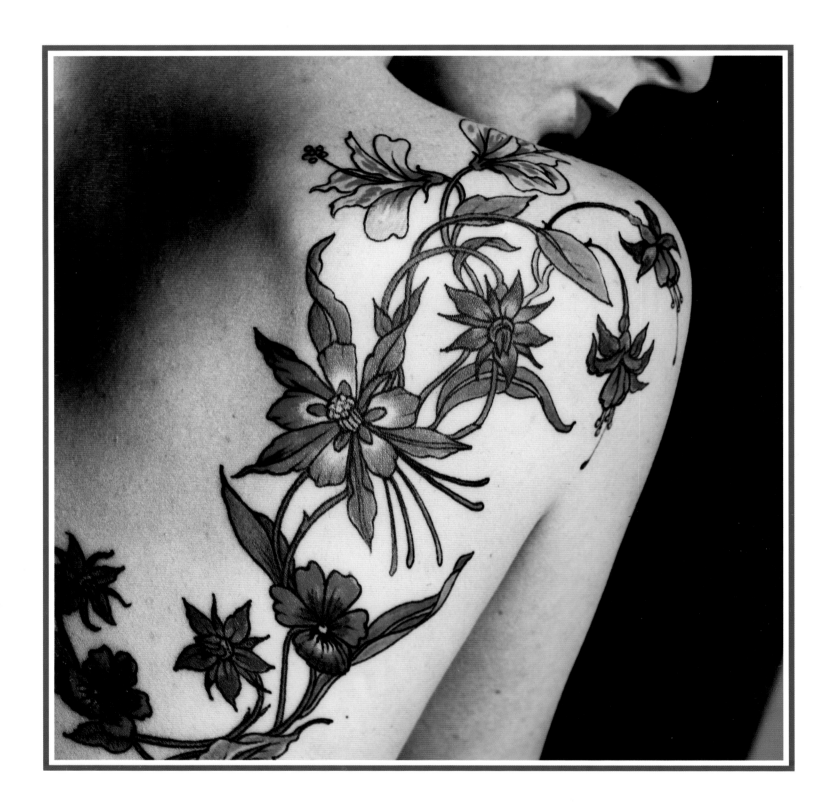

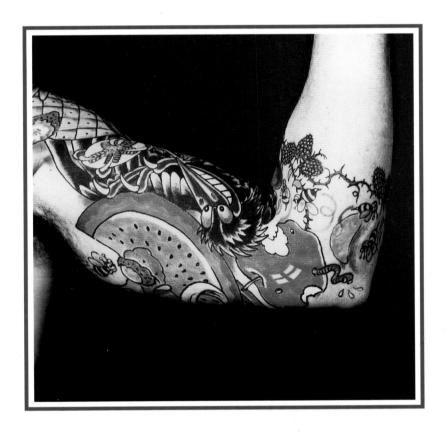

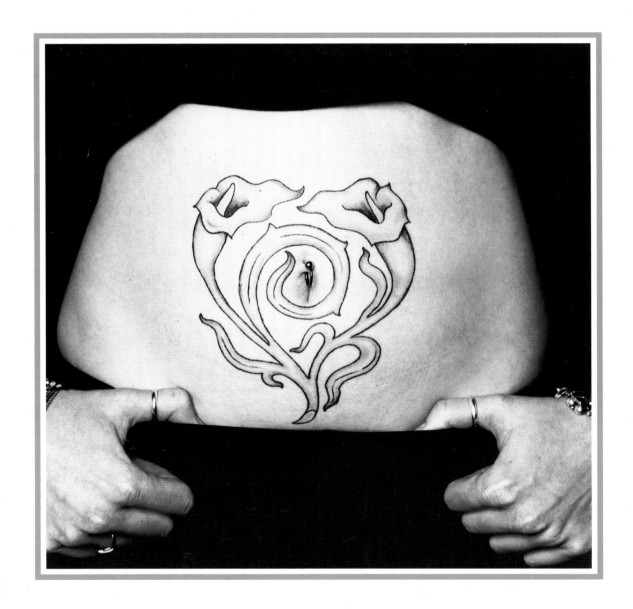

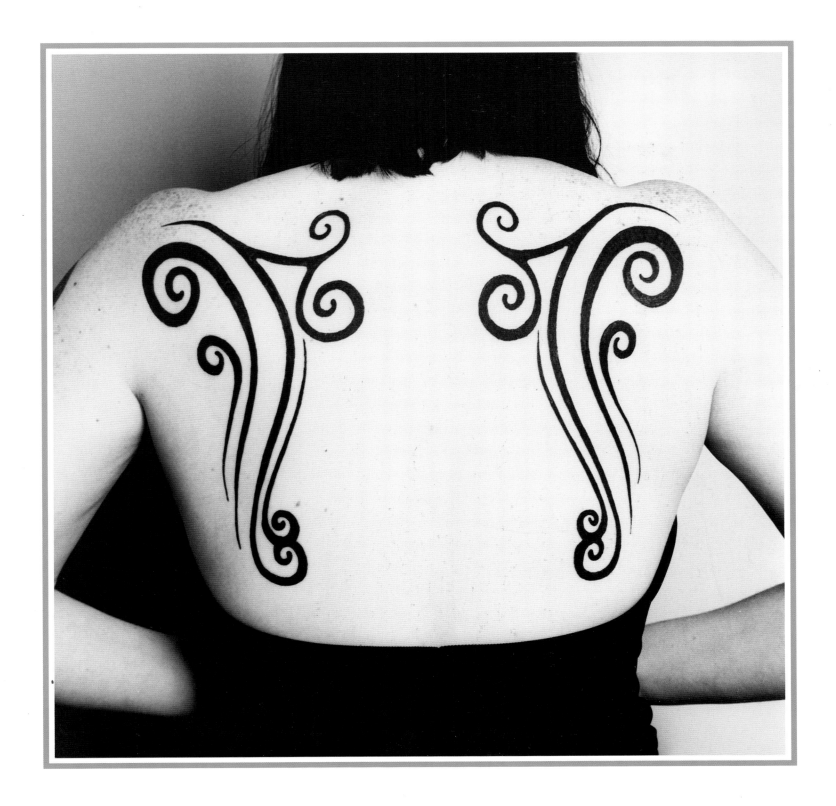

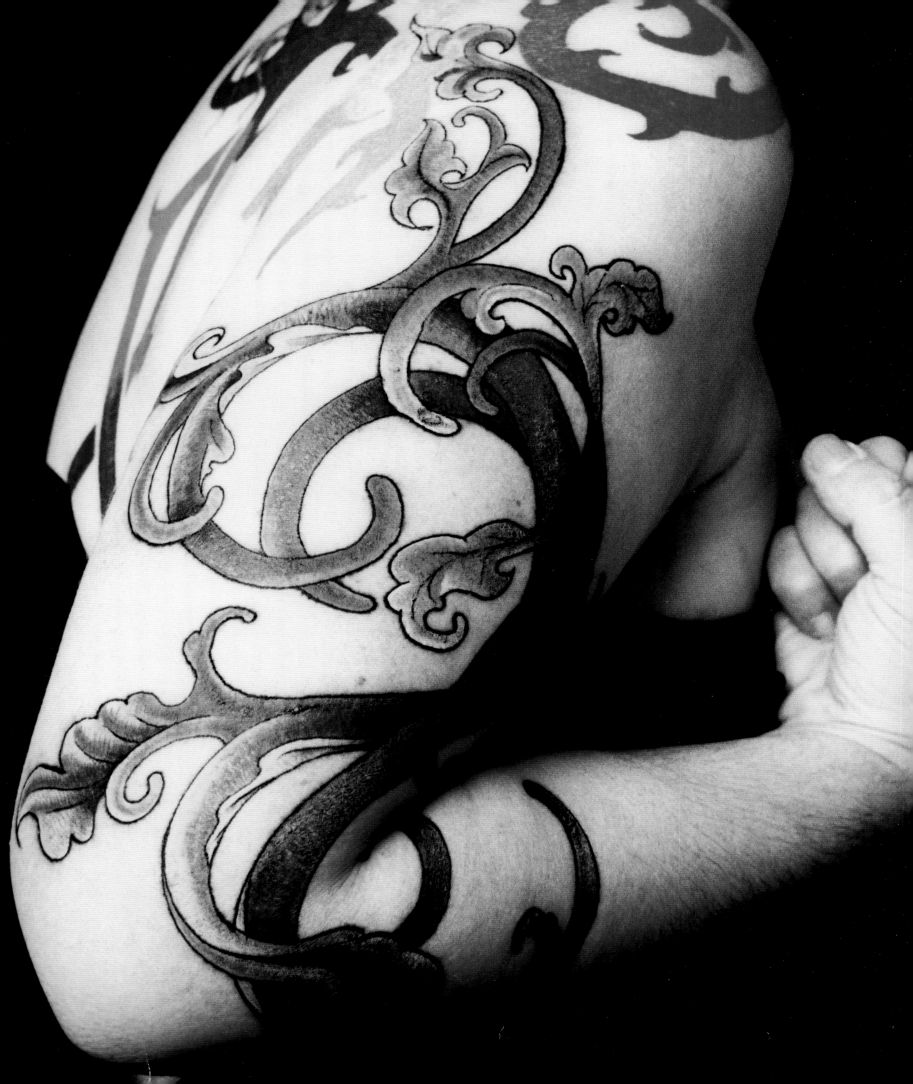

Opposite: VYVYN LAZONGA
ALEX BINNIE

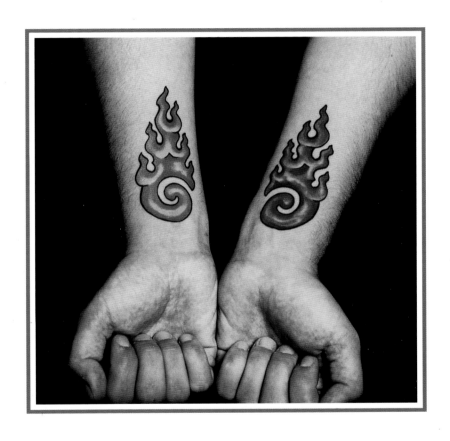

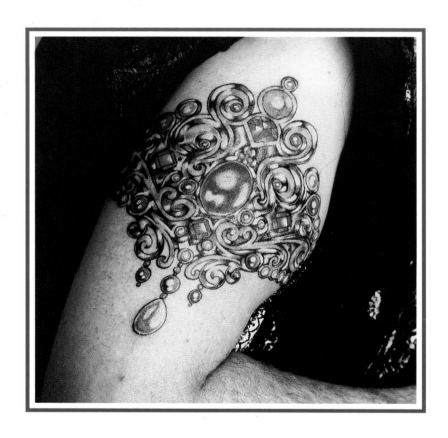

MARCUS PACHECO *(crown)*
FRANK LEE *(chessboard)*

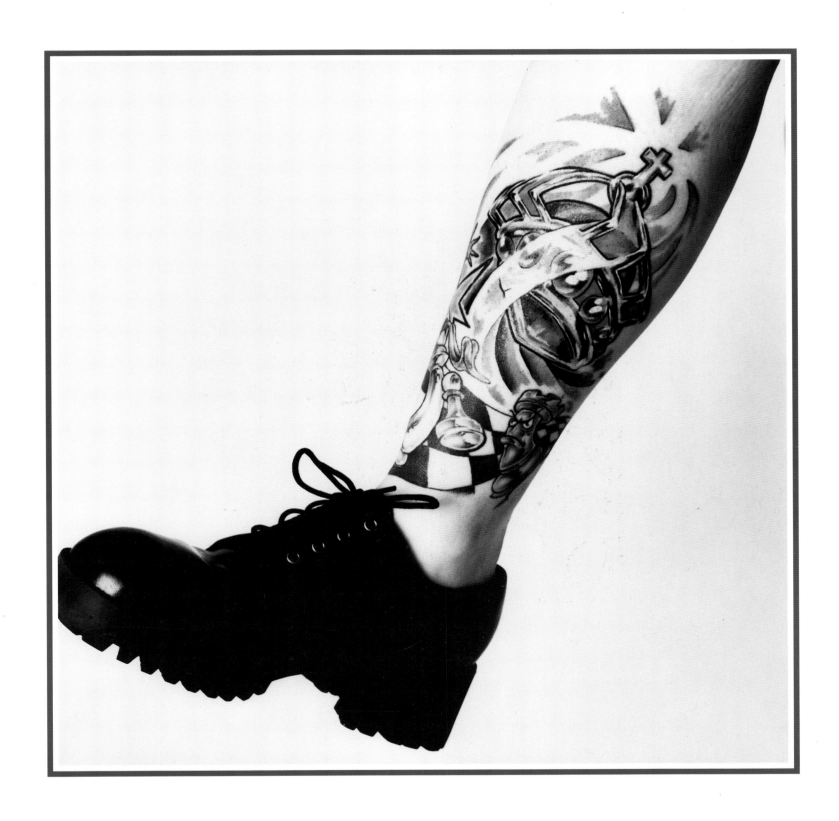

FRED CORBIN *(hands)*
LEO ZULUETA *(her left arm)*
BILL SALMON *(her right arm)*
MARCUS PACHECO *(necklace)*

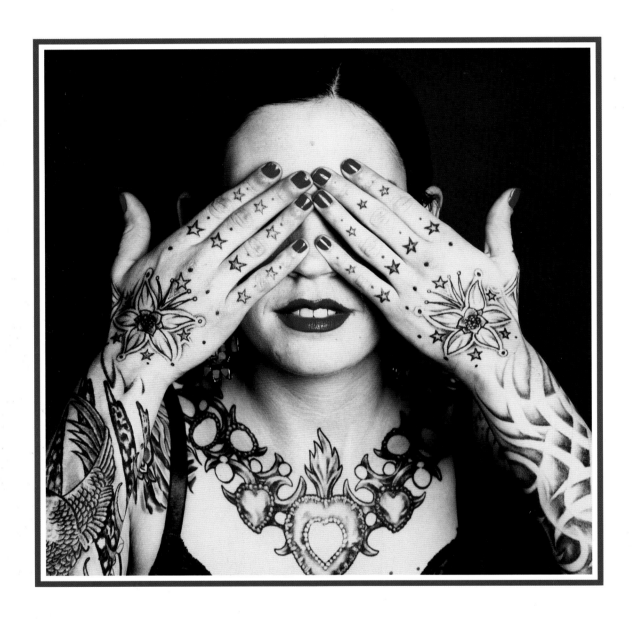

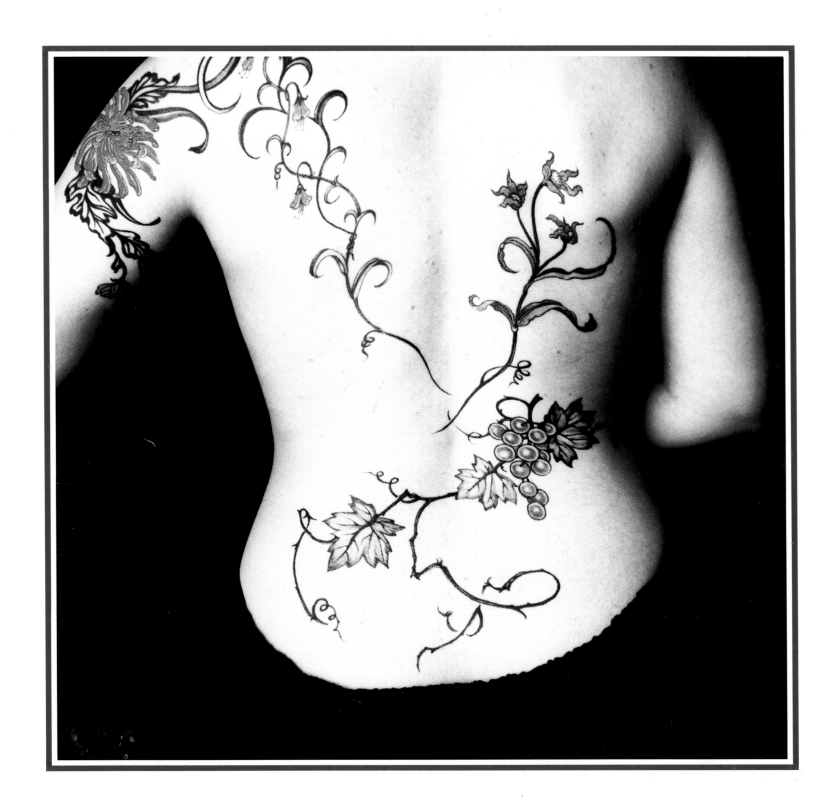

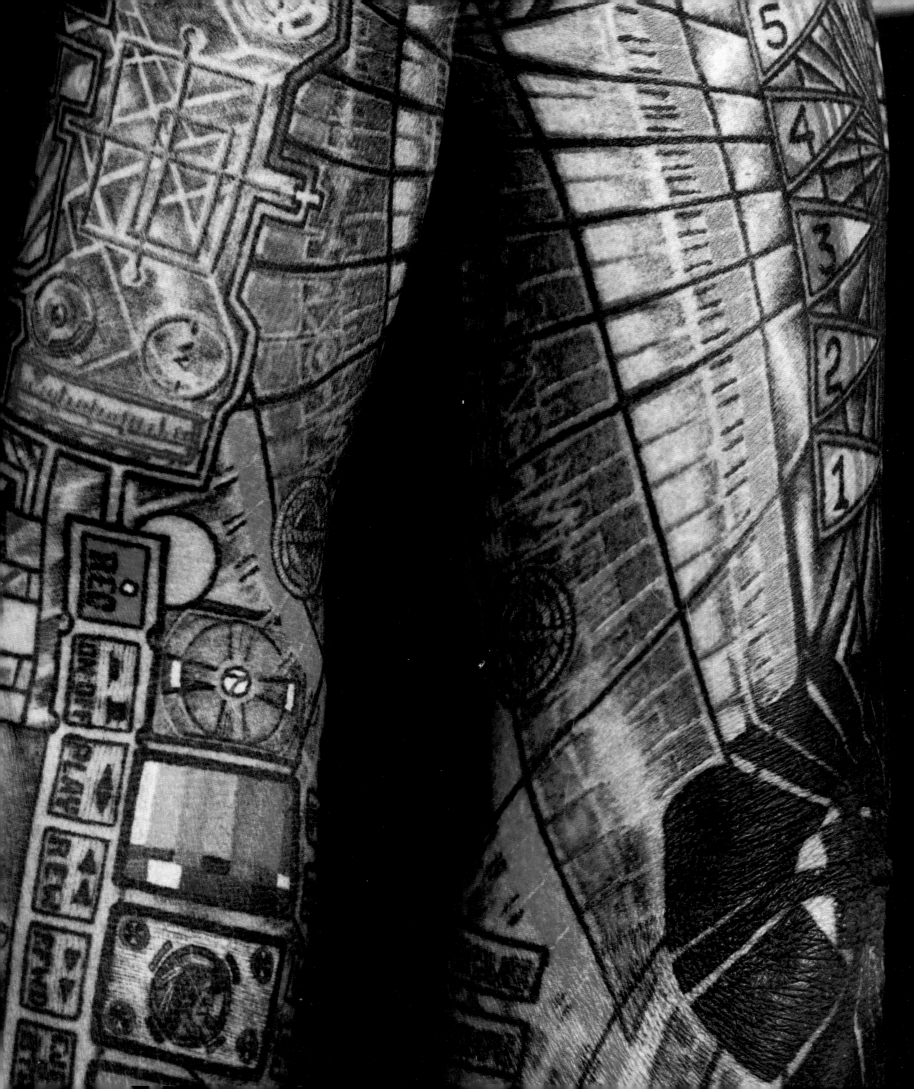

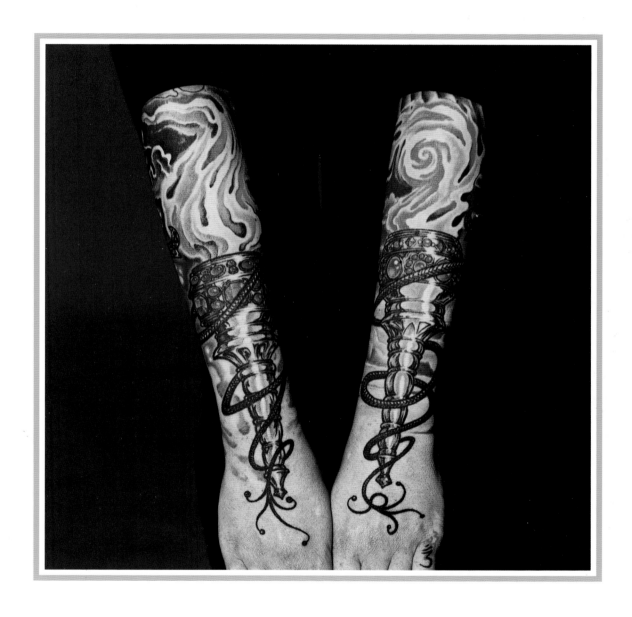

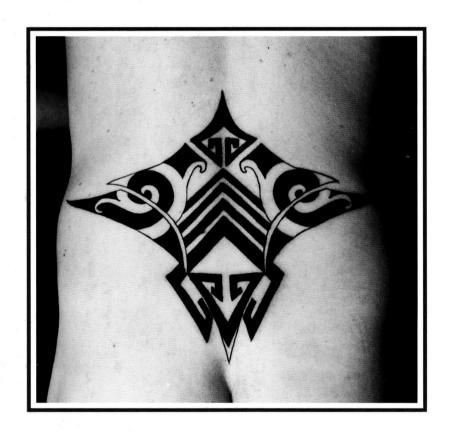

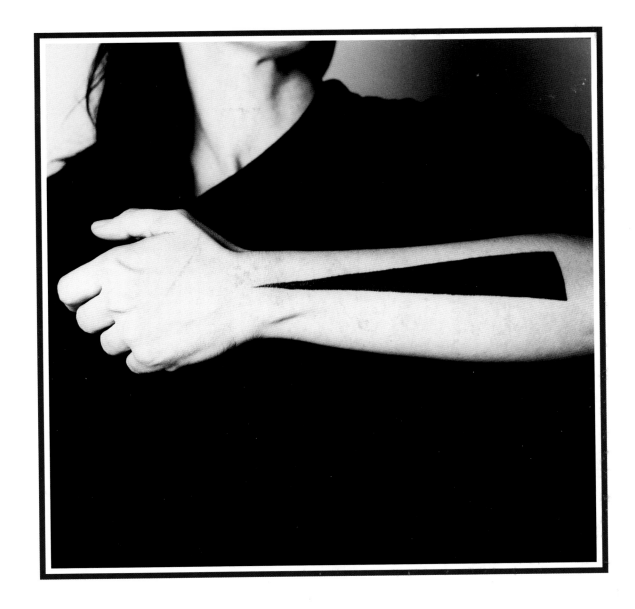

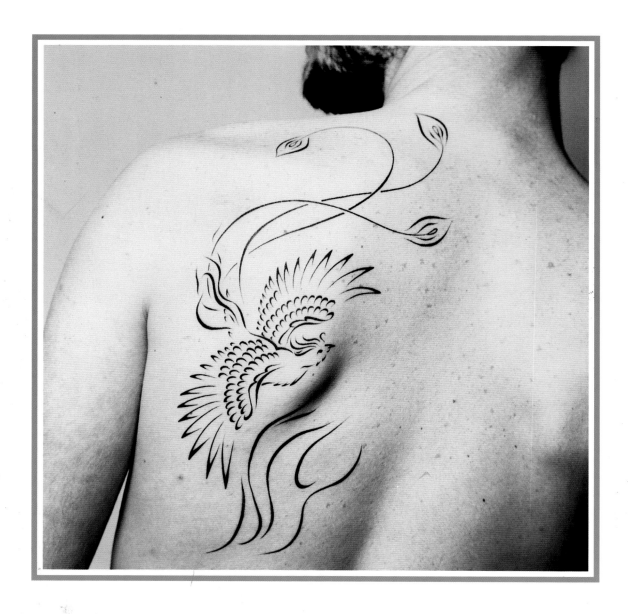

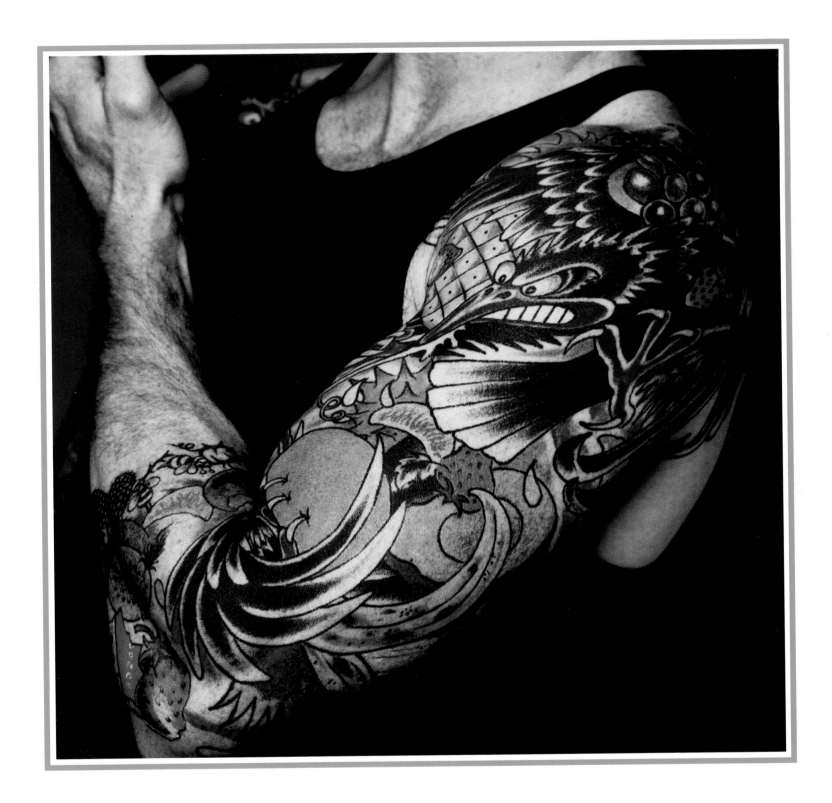

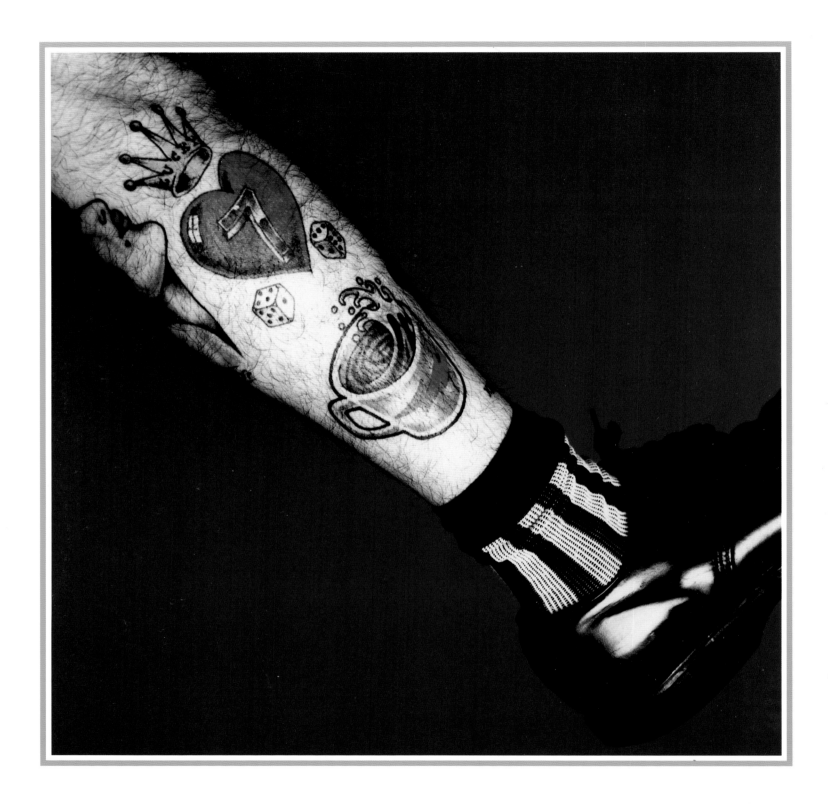

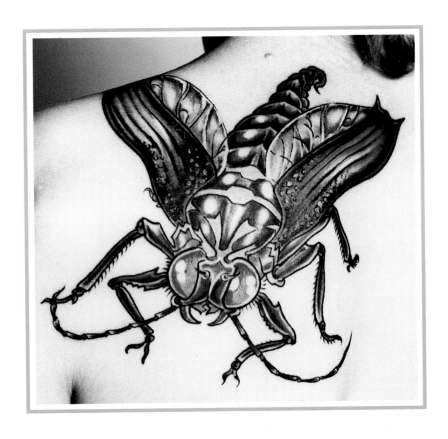

The Tattoo Process: Questions and Answers

Getting a tattoo today is a very different proposition than it was even ten years ago. But there are still plenty of hurdles to be leapt, including widespread suspicion and prejudice about the process. According to the Alliance of Professional Tattooists, the practice remains illegal in Oklahoma, Massachusetts, and South Carolina, as well as assorted cities, including New York and Atlanta. The laws concerning tattooing seem to change almost daily, and the legal age depends on the whims of each state.

Before acquiring a tattoo, there are a lot of questions to ask. What follows are some of the ones most frequently raised, with responses gleaned from a variety of sources in the tattoo world, including many of the artists and clients themselves, as well as the myriad books and magazines available to those interested in pursuing their tattoo studies further.

How Is a Tattoo Made?

In the most basic terms, tattooing is the process of puncturing the skin and depositing pigments below its surface. As discussed earlier, many different materials and techniques are used to create tattoos, but I will limit myself here to the modern Western method, which employs an electric, hand-held tattoo machine. This lightweight metal object looks like a mutated, top-heavy ballpoint pen, and it sounds a lot like a dentist's drill. It is operated by a foot pedal, with a variable speed controlled by a rheostat and determined by the tattooist, depending on personal preference and the type of work being done. Generally, two separate machines are used to create any given tattoo: a liner (to draw whatever outlines are necessary) and a shader (for filling in).

Contrary to popular assumptions, tattoo needles are not hollow. In fact, insect-mounting pins or commercial sewing needles are favored, bound and soldered (usually by the tattooist) to form a group that holds the ink. The type of design and the tattooist's personal style dictate the number of needles used during the tattoo session, but anything from a single needle (used in fineline tattooing) to a chunkier bundle of over fifteen (for large-scale tribal motifs, for instance) is common.

To begin the session, the area to be tattooed is prepared by cleaning, disinfecting, and if necessary, shaving. The selected design is then transferred to the client's skin by one of several means, including free-hand drawing or a variety of stencil techniques. A smooth, taut surface is optimum, so the skin will be stretched tight by the tattooist as he or she works.

Is It Bloody?

The preconception that tattooing is a gory process just isn't accurate (if it *were* terribly bloody, the ink would be washed out of the skin). A certain amount of bleeding is expected, but a skilled tattooist's needles don't penetrate the skin deeply enough to cause much of it. However, as with any body-altering process, there are exceptions, and you should check with your doctor if you have any concern about the effects of tattooing on your own system. Some tattoo clients bleed more heavily than others, some are slower to heal, and some even register an allergic reaction to the inks. Although all commercial tattoo inks today are advertised as hypo-allergenic, a few clients have reacted to the color red, for instance, and have found the healing process to be somewhat longer and itchier than normal.

After the tattoo has been completed and bandaged, lymph, blood, and some ink will typically seep out, forming a scab that falls away after a week or so (don't pick it!). Within a few weeks the skin heals completely and the new tattoo is ready to flaunt.

Is There a Special Tattoo Chair, and Will I Be Alone with the Tattooist?

Barber chairs, massage tables, incline boards—they're all used by tattooists, and everyone has his or her own preferred ways of working. In the more private studio settings, clients are generally seques-

tered alone with the artists, although customers are free to bring a friend, and some tattooists working on intimate body parts prefer to have a third person around as a witness. In street shops several customers may be tattooed simultaneously, as in beauty salon stations, and privacy is often more limited. It is considered good form to ask before gawking at someone being tattooed.

Will It Hurt?

This is the place to dispel one tattoo myth—namely, that getting a tattoo is excruciatingly painful. The level of discomfort depends on a couple of things: placement and pain threshold. Soft, fleshy areas like the biceps, buttocks, or shoulders are less sensitive than protected spots like the underarm and inner thigh, while bony areas like the ankle and spine are usually more painful. Everyone has a different tolerance for pain, and so reports on the tattoo process vary widely. If you are really worried, ask for a trial run without ink to see how you cope with the experience.

Every tattooist has a personal opinion about handling whatever pain results from the process. Some recommend taking a painkiller like Ibuprofen beforehand; others prefer their customers to be in as pure a state as possible for the procedure. To many devotees, the ritual aspect of tattooing includes the inherent discomfort, and many comment on the adrenaline/endorphin surge that accompanies the process. Average sessions, lasting an hour or two (excluding work on the most tender areas), are often described more as an irritation than as the all-out torture many people expect.

Is It Safe?

According to the Center for Disease Control in Atlanta, which in 1985 issued national guidelines for protection during the tattoo process, there has never been a recorded case of tattoo-transmitted HIV infection; the last reported tattoo-related incident of hepatitis was in 1950. Any self-respecting tattoo studio now resembles an art-studio-cum-dentist's-office: rubber gloves, disinfectant soap, disposable ink cups, and sterilizing autoclaves are the rule, to protect both the client and the artist. If you don't feel satisfied that the tattooist or studio is meeting health requirements (if there is no autoclave or disinfecting soap, for instance), take your business elsewhere.

How Do I Find the Right Tattoo Artist?

The success of any artistic tattoo depends on a collaborative relationship between receptive client and skilled artist. As in any field, there are interlopers, dabblers, and inept hucksters jostling for space on the bandwagon, but with creative tattooists now in almost every city, no one should settle for hack work. A poorly executed art work has profound implications when it is part of your epidermis for the rest of your life.

There are plenty of ways to find an artist to create your tattoo, but first decide how committed you are. It is not unusual for connoisseurs to travel to distant cities collecting work by masters in the field. If you'd rather stay close to home, one of the easiest things to do is simply ask someone who has a tattoo you admire and hope that it was done locally. Or visit the tattoo shops in your area and look at the photos of completed work to see if they reflect a style you like. By all means educate yourself first—pore over the magazines and learn what's well done and what's mediocre so you can recognize a good tattooist's work when you see it. The magazines also carry ads and lists of tattoo shops all over the country; they are in no way definitive, but they'll be a good place to start. Finally, attend a tattoo convention if you can, where a wide variety of tattooists and their clients will be all together under one roof. For the dates and cities of these events, consult the magazines.

How Do I Pick the Right Design?

Considering that this is one of the most personal and permanent decisions you are likely to make, don't make it lightly and be as honest with yourself as possible about what you want and why. Again, educating yourself about all the tattoo possibilities will help, unless you have an indelible image already in mind. Providing some visual aid to guide the tattoo artist might be appreciated—for instance, album covers, photographs, art books, illustrations, comics, antique graphic designs, anything that approaches what you envision. But then let the artist do his or her own work, advising you on changes and refinements, applying a particular style or technique, explaining why something might or might not look good. Asking an artist to copy someone else's tattoo is rather insulting, and something unique is a far better choice.

How Much Will It Cost?

Prices vary depending on the tattooist, the size and complexity of the tattoo, and whether the design is custom or flash. A small tattoo in a street shop might cost twenty dollars; the *hourly* rate for a custom piece by an established artist can run between a hundred and two hundred fifty dollars. You should expect a nonbinding oral estimate based on the tattoo's design, size, and placement; usually the only written estimates are those resulting from correspondence between a client and a tattoo artist living in different cities.

How Long Does It Take?

This depends on the tattoo, of course, as well as on the speed of the tattooist and the duration of each session. A dainty little rosebud may take only fifteen minutes to complete; an intricate full-back piece can be weeks or months in the making. Figure on a single one- to three-hour session for the average five-inch-square tattoo. There are plenty of stories about eight- or ten-hour marathons for more complex tattoos, but these are grueling for both artist and client; a couple of three- or four-hour sessions are often preferable, considering the intense, focused nature of the work.

What Maintenance Does a Tattoo Require?

Once a tattoo is in place, its future depends on several factors, and most tattooists have printed care instructions that they give to their clients. Typically, a new tattoo will scab over immediately and then heal in a few weeks; during that period direct sunlight should be avoided or else the color can fade.

Sunlight, in fact, is the enemy of tattoos, but proper protection with clothing and/or sunscreen can keep high-quality work looking pristine even after several decades have passed. And, if the color eventually needs brightening, it is not uncommon to be re-inked.

Can I Get Rid of It?

Tattooing should never be considered anything less than permanent since the removal process is expensive, time consuming, and not necessarily pleasant. Before medical solutions are sought, a tattooed "cover-up" should be considered, since many a poorly made, outgrown, or otherwise unloved tattoo has been cleverly disguised by the added work of a skilled artist. Carefully planned and colored overlays can turn unwanted tattoos into finely wrought creations, without a hint of the earlier work.

But if utter obliteration is the only solution, there is now hope for successful removal. Until recently, the removal process was fairly barbaric, relying on surgical incisions, dermabrasion, or chemical salabrasion, all of which cures were often less satisfactory than the problem. Recently, laser technology—particularly the high-tech pulse lasers—has opened up new possibilities for erasing tattoos.

Developed in the 1980s, the Medlite, Dermalase, and Alexandrite lasers deliver short bursts of energy that are selectively absorbed by the tattoo ink; this process breaks up the tattoo pigment, which is gradually eliminated from the body. According to my conversations with dermatologist Dr. Steven B. Snyder (in Owings Mills, Maryland), who has removed hundreds of tattoos and is recommended by the Alliance of Professional Tattooists, the combined use of Medlite and Dermalase beams is important since each is effective on different pigment colors. The Alexandrite laser, while touted as removing all colors, requires more treatments and expense.

Dr. Snyder cautions that even though the combined approach most often does not result in a permanent scar: "Any cosmetic procedure always carries some risk due to individual patient responses, and there is a 1 to 3 percent chance for some change in the skin. But the great majority of tattoos can be removed without scarring." The pulse-laser process costs, on average, between two hundred and three hundred dollars per treatment, with the length and number of treatments depending on the size of the tattoo. For example, a typical two-by-three-incher takes about twenty minutes; a three-by-five-inch tattoo can require up to three treatments, and large tattoos are tackled in ten-by-ten-inch segments. Snyder describes the process as feeling "like a rubber-band snap with each pulse," and half of his patients choose to forgo a local anesthetic.

Notes

1. Robert S. Bianchi, "Tattoo in Ancient Egypt," in Arnold Rubin, ed., *Marks of Civilization* (Los Angeles: Museum of Cultural History, UCLA, 1988), p. 22.
2. Sergei Rudenko, *Frozen Tombs of Siberia: The Pazyryk Burial of Iron Age Horsemen* (Berkeley: University of California Press, 1970), p. 112.
3. Clinton R. Sanders, *Customizing the Body: The Art and Culture of Tattooing* (Philadelphia: Temple University Press, 1989), p. 9.
4. Herodotus, "The History," in *Great Books of the Western World,* vol. 5 (Chicago: Encyclopaedia Britannica), pp. 161, 166.
5. Donald McCallum, "Historical and Cultural Dimensions of the Tattoo in Japan," in Rubin, ed., *Marks of Civilization,* p. 111.
6. Joy Gritton, "Labrets and Tattooing in Native Alaska," ibid., p. 181.
7. Henri Hubert, *The Rise of the Celts* (New York: Alfred A. Knopf, 1934), p. 203. Jocelyn Paine, "Skin Deep: A Brief History of Tattooing," *Mankind* 6 (May 1979): 21.
8. William C. Sturtevant, introduction to C. H. Fellowes, *The Tattoo Book* (Princeton, N.J.: Pyne Press, 1971), p. 2.
9. R.W.B. Scutt and Christopher Gotch, *Art, Sex and Symbol: The Mystery of Tattooing* (South Brunswick, N.J.: A. S. Barnes, 1974), p. 26.
10. Edward A. Freeman, *The History of the Norman Conquest of England* (Chicago: University of Chicago Press, 1974), p. 217.
11. Sanders, *Customizing the Body,* p. 14.
12. Paine, "Skin Deep," p. 42.
13. Marco Polo, in Sir Henry Yule, *The Travels of Marco Polo,* vol. 2 (New York: Charles Scribner's Sons, 1926), p. 84.
14. Ibid., p. 117.
15. Sturtevant, introduction to Fellowes, *Tattoo Book,* p. 5.
16. Scutt, *Art, Sex and Symbol,* p. 36.
17. Ibid., p. 42.
18. Ibid., p. 43.
19. McCallum, "Historical and Cultural Dimensions of the Tattoo in Japan," p. 124.
20. Sturtevant, introduction to Fellowes, *Tattoo Book,* pp. 7–8.
21. Ibid., p. viii.
22. Sanders, *Customizing the Body,* p. 17.
23. Marcia Tucker, "Pssst! Wanna See My Tattoo. . . ," *Ms.* 4 (April 1976): 29.
24. Arnold Rubin, "The Tattoo Renaissance," in Rubin, ed., *Marks of Civilization,* p. 236.
25. D. E. Hardy, *Eye Tattooed America* (Chicago: Ann Nathan Gallery; Honolulu: Hardy Marks Publications, 1993), p. 14.

Selected Bibliography

BOOKS

Burchett, George, and Peter Leighton. *Memoirs of a Tattooist.* London: Oldbourne, 1958.

Fellman, Sandi. *The Japanese Tattoo.* New York: Abbeville Press, 1986.

Fellowes, C. H. *The Tattoo Book.* Introduction by William C. Sturtevant. Princeton, N.J.: Pyne Press, 1971.

Hambly, Wilford D. *The History of Tattooing and Its Significance.* London: Witherby, 1925.

Hardy, Don Ed. *Rocks of Ages.* Honolulu: Hardy Marks Publications, 1992.

————. *Eye Tattooed America.* Chicago: Ann Nathan Gallery; Honolulu: Hardy Marks Publications, 1993.

Parry, Albert. *Tattoo: Secrets of a Strange Art as Practiced among the Natives of the United States.* New York: Simon and Schuster, 1933.

Richter, Stefan. *Tattoo.* London and New York: Quartet Books, 1985.

Rubin, Arnold, ed. *Marks of Civilization.* Los Angeles: Museum of Cultural History, UCLA, 1988.

St. Clair, Leonard, and Alan Govenar. *Stoney Knows How: Life as a Tattoo Artist.* Lexington: University Press of Kentucky, 1981.

Sanders, Clinton R. *Customizing the Body: The Art and Culture of Tattooing.* Philadelphia: Temple University Press, 1989.

Scutt, R.W.B., and Christopher Gotch. *Art, Sex and Symbol: The Mystery of Tattooing.* South Brunswick, N.J.: A. S. Barnes, 1974.

Steward, Samuel. *Bad Boys and Tough Tattoos: A Social History of the Tattoo with Gangs.* New York: Harrington Park Press, 1990.

Vale, V., and Andrea Juno, eds. *Modern Primitives: An Investigation of Contemporary Adornment and Ritual.* San Francisco: Re/Search Publications, 1989.

Webb, Spider. *Pushing Ink: The Fine Art of Tattooing.* New York: Simon and Schuster, 1979.

Wroblewski, Chris. *Tattoo: Pigments of Imagination.* New York: Alfred van der Marck, 1987.

PERIODICALS

International Tattoo Art, bimonthly. New York.

Outlaw Biker Tattoo Review, monthly. New York.

Skin and Ink, bimonthly. Beverly Hills, California.

Skin Art, monthly. New York.

Tattoo, monthly. Agoura Hills, California.

Tattootime, volumes 1–5. Honolulu.

Index

Page numbers in *italic* refer to illustrations.

Adrian 1, Pope, 10
Ainu, 11
Aitchison, Guy, *35, 61, 62, 70, 71, 77, 109*
Albert, Prince of England, 12
Albertis, Lew (Lew the Jew), 14
American style, 12, 79
Amunet (Egyptian priestess), 8–9
Art Nouveau, 95

Baker, Bill, *44*
Benedetti, Robert, *58*
Bible, 10
Binnie, Alex, *2, 20, 24, 28, 32, 33, 37, 40, 100, 103*
Booth, Paul, *60*
Borneo, 21
Brereton, Leo, 21
Britons, 9
Brody, Deborah, *101*
Brunson, Dana, *54, 57, 58, 59*
Burchett, George, 14
Burmese, 9, 10

Cain, Aaron, *65*
Cartwright, Charlie, 17
Chicano barrio culture, 17
Chinese, 10
circuses, 12, 14
Collins, Norman Keith "Sailor Jerry," 15, *15*, 16, 17, 18
Conn, Chris, *53, 66, 69, 88, 90, 93*
Constantine, Emperor, 10
Constantin, Prince, 12
Cook, Captain James, 10–11
Corbin, Fred, 17, *26, 27, 56, 72, 85, 106*
counterculture tattooing, 15–16
Crocker, Amy, 12
Crusaders, 10

Dalí, Salvador, 43
Deutsche, Eddy, 17, *27*
Duchamp, Marcel, 43

Edward, Prince of Wales, 10
Egyptians, 8–9

electric needle, 14
Eskimos, 9, 10
Europe, 12
Everett, Kandi, 17, 21, *29*

Fauser, Suzanne, 17, *38, 46, 55, 98, 107*
"flash," 14, 17, 18
freak shows, 12, 14

George, King of Greece, 12
George, Prince of England, 12
Giger, H. R., 19
Gorman, Shotsie, 17
Grimm, Wes, *76*

Haida, 21, *25*
Hamlet, 43
Hardy, Don Ed, 16, 17, *19, 80, 87, 94, 96, 99, 113*
Harold, King of England, 10
Harrison, Scott, *74, 83, 84, 89, 92, 97*
Hawaiian Islanders, 21
Hendrix, Jimi, 43, *61*
Herodotus, 9
Higgs, Daniel, 17, *51*
Hippocrates, 9
Hopi designs, 21

Iceman, 8
Ingerton, Roger, 21
Irons, Greg, 17

Japan, 9, 11–12, 15
Japanese style, 15, 16, 17, 43, 79, *87*
Jeffries, Paul, *39, 48*
Jeoly, Prince, of Meangis Island, 10, *11*
Jimmu Tenno, Emperor of Japan, 11
Jordan, Jill, *4*, 17, *28, 30, 42, 49, 50, 52, 67, 68, 82, 91, 104, 115*

Kintaro, 15
Koran, 10
Kosmala, Gary, *25*
Kotker, David, *31*

Laos, 10
laser removal of tattoos, 118

Lazonga, Vyvyn, 17, *102, 110*
Lee, Frank, *105*
Leu, Filip, *86*
Lloyd, Lance, *36*

Malone, Michael, 17, 21
Maoris, 9, 11, *12, 13*, 21
Marco Polo, 10
Mast, Steven, *58*
Matsuhito, Emperor of Japan, 12
Max, Mr., *46*
Micronesia, 21
moko (Maori tattooing), 11, *12, 13*
Moslems, 10
Munch, Edvard, 43
Museum of American Folk Art, 16

Native Americans, 9, 10, 95
Nazis, 16
Negrete, Freddy, 17
Nicholas II, Czar, 12
nomadic peoples, 9

Omai of Tahiti, 10
O'Reilly, Samuel, 14

Pacheco, Marcus, *65, 73, 92, 105, 106*
Picts, 9–10
Polynesians, 10–11, 21
Pomponius Mela, 9

Quinn, Kevin, *78*

Rassier, Jeff, *75*
Raven, Cliff, 16–17, 21
Rinks, Matt, *111*
Roberts, Bob, 17, *81*
Rock of Ages design, 79
Romans, 10
royalty, tattooing among, 10, 12
Rudy, Jack, 17

Sacred Heart design, 79
Salmon, Bill, *4*, 17, *64, 106, 108*
Schongauer, Martin, 43, *44*
Sea Dayak (Borneo), 21
Shiva (Hindu god), *63*
Snyder, Dr. Steven B., 118
Sparrow, Phil (Sam Steward), 16, 17

Suikoden (Water Margin), 12, 15
Summers, Jamie, 17

tattaugraph, 14
tattoo, origin of word, 11
tattooing: artistic, 15–19; colors available for, 43; cost of, 117; health concerns regarding, 117; history of, 8–19; legality of, 12, 116; misconceptions about, 7–8; popularity of, 8, 12, 14, 15–16, 18–19; process of, 14, 18, 116–18; profession of, 14–15, 18; reasons for, 8–9, 14; religious decrees against, 10; removal of, 118; shops and studios, 18, 116; subject matter of, 14–15, 17–19, 95; training for, 18; underground/deviant associations of, 11, 12, 14, 16
Tattootime (periodical), 17
Thomé, Dan, 21
Tibetan designs, 95

van Gogh, Vincent, 43
Vessels, Robert, *6*
Vida, Laura, 17, *47, 112*

Waldemar, Princess of Denmark, 12
Whitehead, Jef, *45, 114*
Wilhelm, Kaiser, 12
Williams, Robert, 19

Xenophon, 9

Zulueta, Leo, 21, *22, 23, 34, 40, 41, 106*

Photography Credits

From *Sailor Jerry: American Tattoo Master*, copyright © 1994 Hardy Marks Publications; courtesy Michael Malone: page 15. Tattoo Archive, San Francisco: pages 11–13.